D0772054

# FOLK DESIGNS FROM INDIA

## IN COLOR

Pradumna and Rosalba Tana

DOVER PUBLICATIONS, INC., NEW YORK

Published in Canada by General Publishing Company, Ltd., 30 Lesmill Road, Don Mills, Toronto, Ontario.
Published in the United Kingdom by Constable and Company, Ltd., 10 Orange Street, London WC2H 7EG.

*Folk Designs from India in Color* is a new work, first published by Dover Publications, Inc., in 1987.

DOVER *Pictorial Archive* SERIES

Manufactured in the United States of America
Dover Publications, Inc., 31 East 2nd Street, Mineola, N.Y. 11501

**Library of Congress Cataloging-in-Publication Data**

Tana, Pradumna.
  Folk designs from India in color.

  (Dover pictorial archive series)
  1. Decoration and ornament—India—Kachchh—Themes, motives. 2. Decoration and ornament—India—Saurāshtra—Themes, motives. 3. Folk art—India—Kachchh—Themes, motives. 4. Folk art—India—Saurāshtra—Themes, motives.
I. Tana, Rosalba. II. Title. III. Series.
NK1476.A3K338  1987    745.4'495475  86-24316
ISBN 0-486-25334-1

# INTRODUCTION

This collection features 47 plates of flora, fauna and figural motifs from folk textiles of the Kutch and Saurashtra regions of Gujarat state in westernmost India. The means employed in their realization—cloth, needle and thread—combine to create a sense of spontaneity, vigor and gaiety. Whether it is an intricate embroidery or a bold appliqué, each piece reflects the innate folk ability to transform realistic images into new, highly stylized decorative or even abstract motifs. The motifs appear in an unending variety: from traditional to contemporary, changing from area to area and community to community yet remaining within the canons established by tradition. This inexhaustible, deeply stimulating inventiveness is the most enchanting aspect of all true folk art.

Home of several distinct ethnic groups, the regions of Kutch and Saurashtra of Gujarat state are extremely rich in the field of folk textiles. Despite the increasing onslaught of industrialization, many tribal communities inhabiting secluded areas of these arid regions have not yet given up their old traditions. Beautiful home-embroidered clothes and household textiles still constitute an essential part of life: for instance, they are a necessity for every bride's trousseau. Thus, embroidery and appliqué are still active art forms. In this part of India there are several different "schools," a few in definite decline or even extinct by now, some still flourishing. They take their denomination from the name of the community responsible for their origin and growth, such as Kathi, Rabari, Ahir and Kanbi.

The subjects of the embroideries and appliqués reflect their origins as well: we see the common local animals of this region of India, including the camel, cow and elephant. Among the plant motifs, the tree of life has been a theme in Indian folklore from time immemorial, and is expressed here in several different forms.

The range of embroidered and appliquéd articles included in this selection is greatly varied, but can be divided into three broad categories: (1) personal clothing—body drapes such as saris and shawls, tunics, gowns, blouses and shirts; (2) textiles for household decoration—small and large wall hangings, door friezes and canopies;

and (3) articles of daily use—quilts, coverlets, cradle cloths, cushions and purses.

The basic fabric used for most of the articles is normally *khaddar,* a strong, handspun, handwoven cotton cloth of great durability. Clothing for festive and special occasions is usually made of elaborately embroidered silk. The embroidery, done in floss silk as well as colored cotton thread, is further enriched by a quantity of small mirrors inserted here and there. The appliqué work is the product of several communities, especially Kathi, Rabari and Mahajan. The stitches most commonly employed are chain stitch and line stitch, used generally for outlining a motif; darn stitch, stem stitch and herringbone stitch, used for filling in the motif; and buttonhole stitch for holding the tiny mirrors in place.

Whatever their differences, common to all these beautifully embroidered and appliquéd articles is that they are the products of painstaking labor and love, infinite patience and many hours employed in their realization. These are articles meant strictly for personal use and destined to be precious heirlooms for future generations. They give us a privileged view of Indian life and the beauty that can arise from the creation of "simple" folk needlework.

Pradumna and Rosalba Tana

*Como, Italy*
*November 1986*

# FOLK DESIGNS FROM INDIA

## IN COLOR

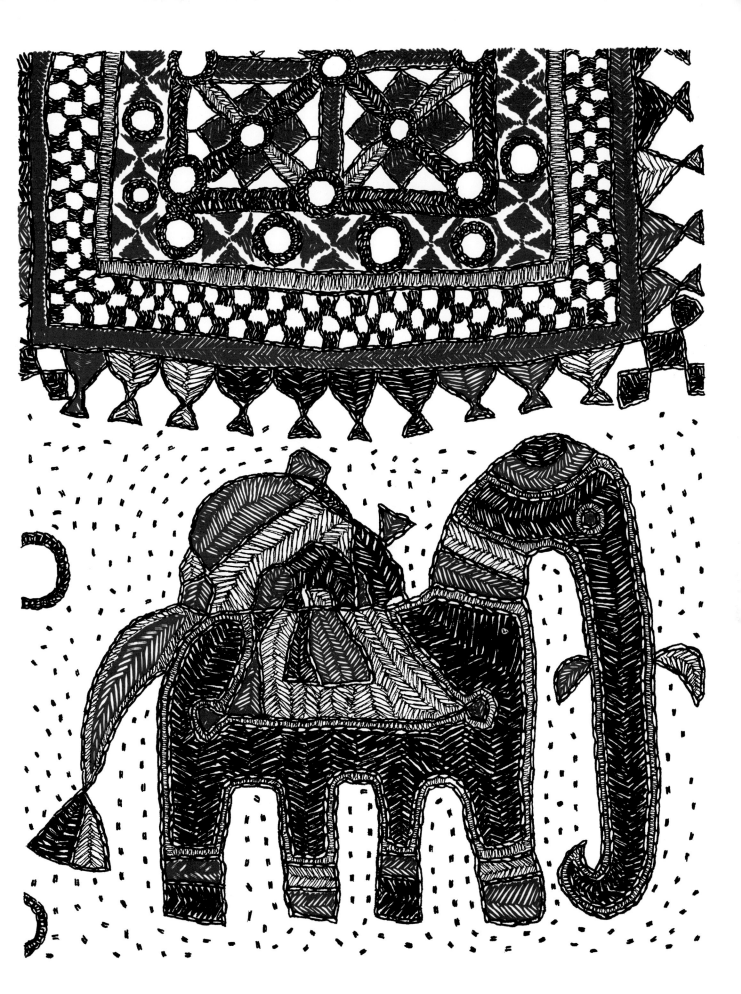

1 Quilted coverlet: elephant. Kathi school, Saurashtra.

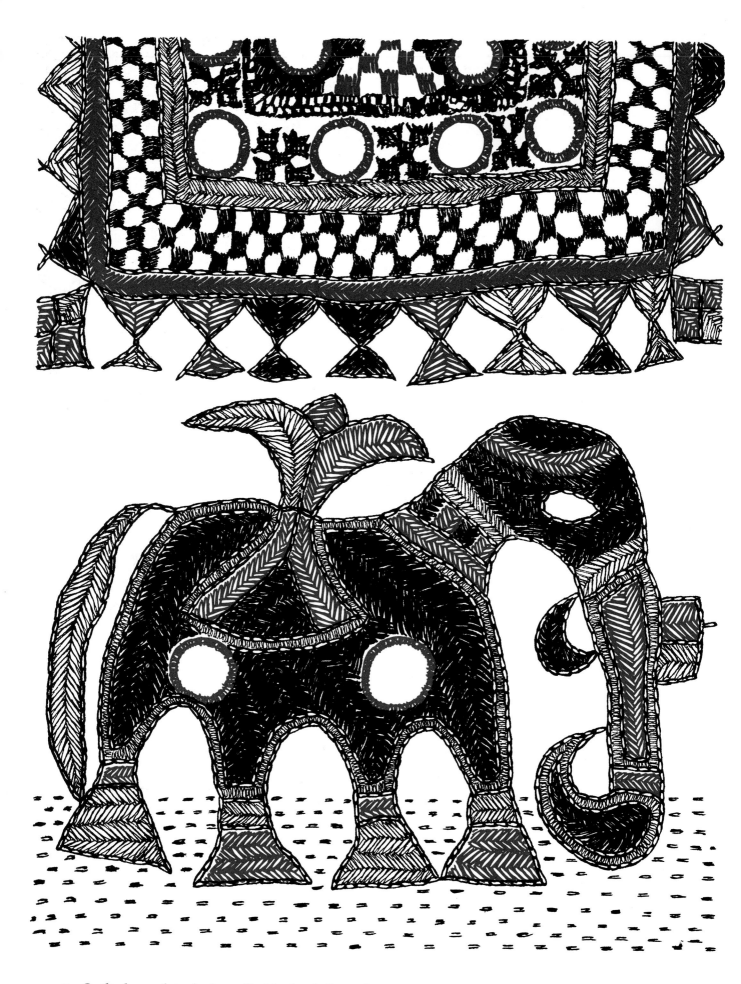

2  Quilted coverlet: elephant. Kathi school, Saurashtra.

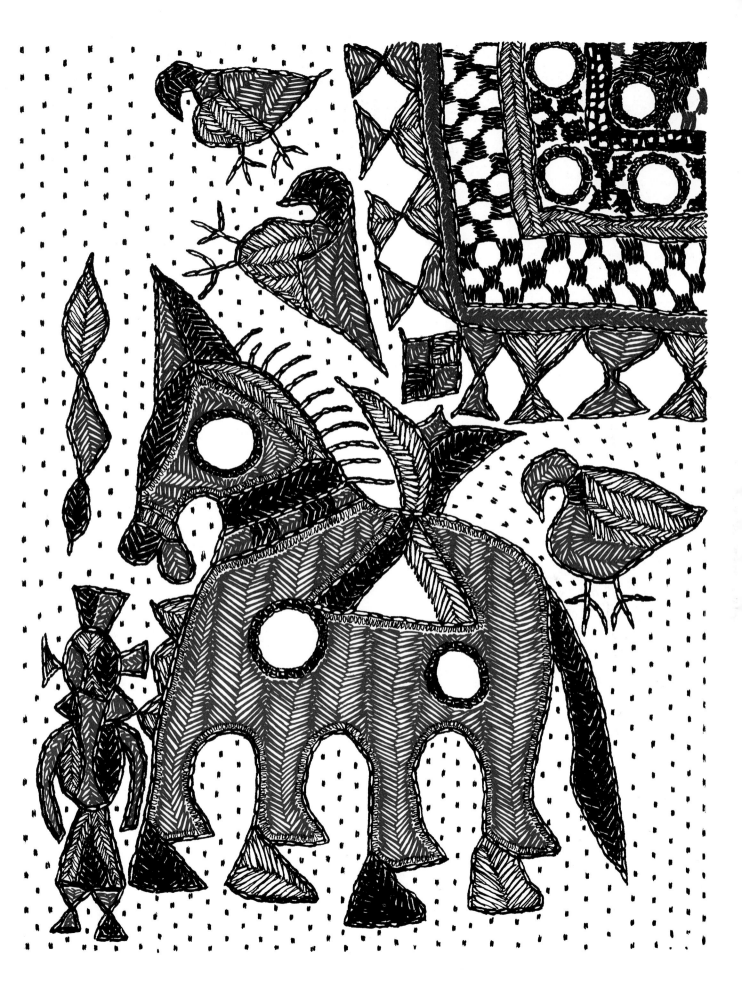

3   Quilted coverlet: man, horse and birds. Kathi school, Saurashtra.

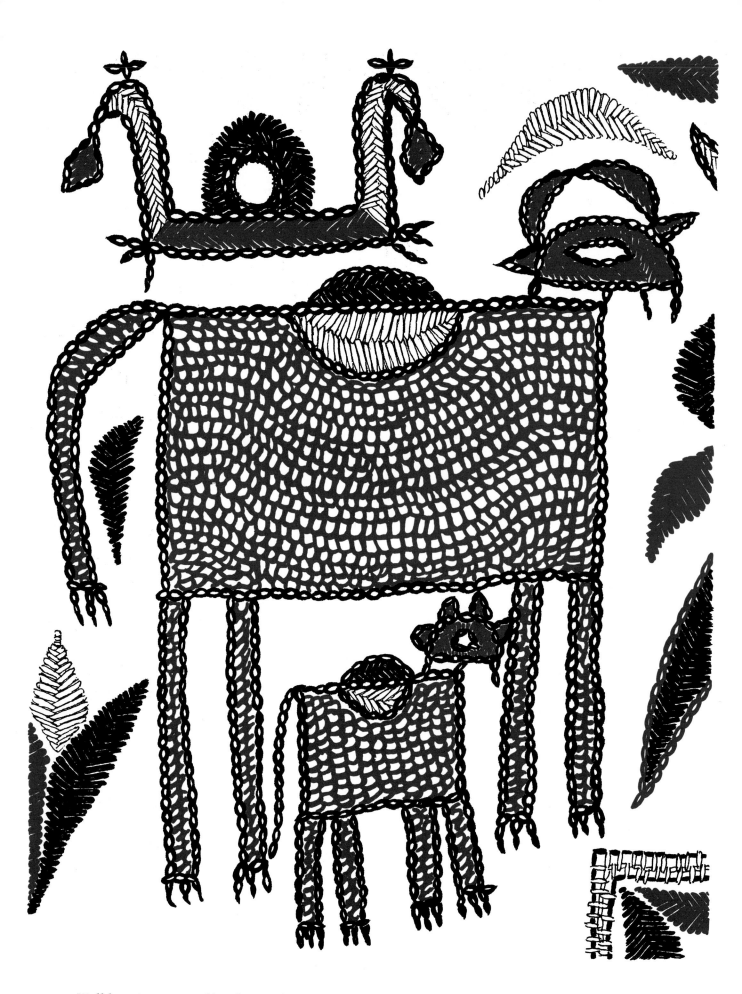

4  Wall hanging: cow, calf and peacock. Kanbi school, Saurashtra.

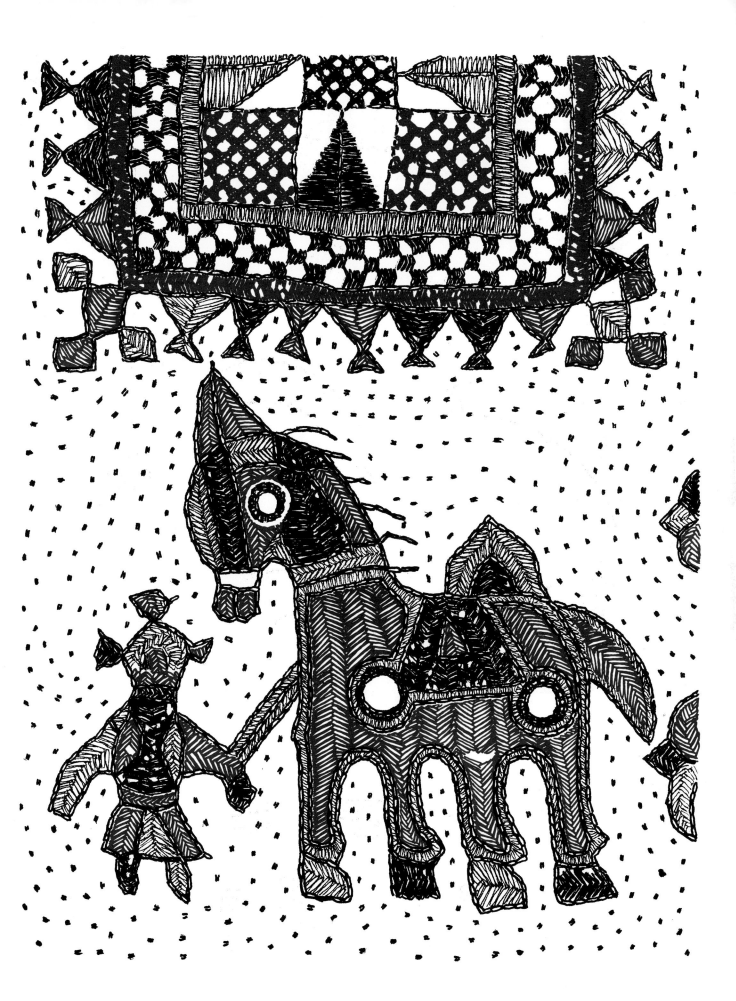

5   Quilted coverlet: man and horse. Kathi school, Saurashtra.

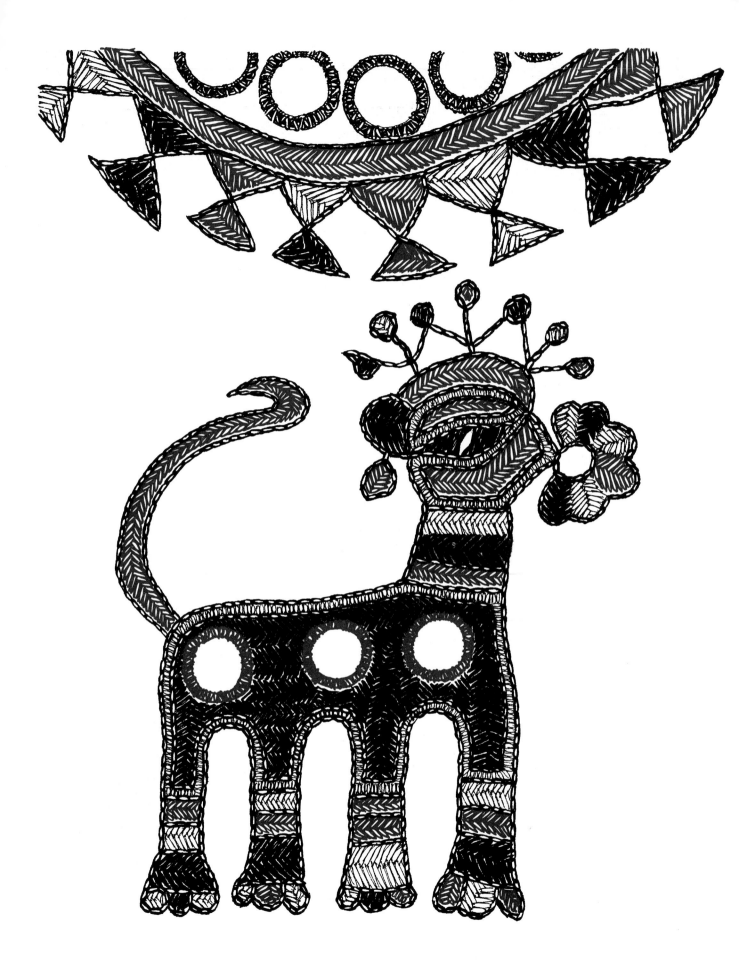

6   Wall hanging: calf. Kanbi school, Saurashtra.

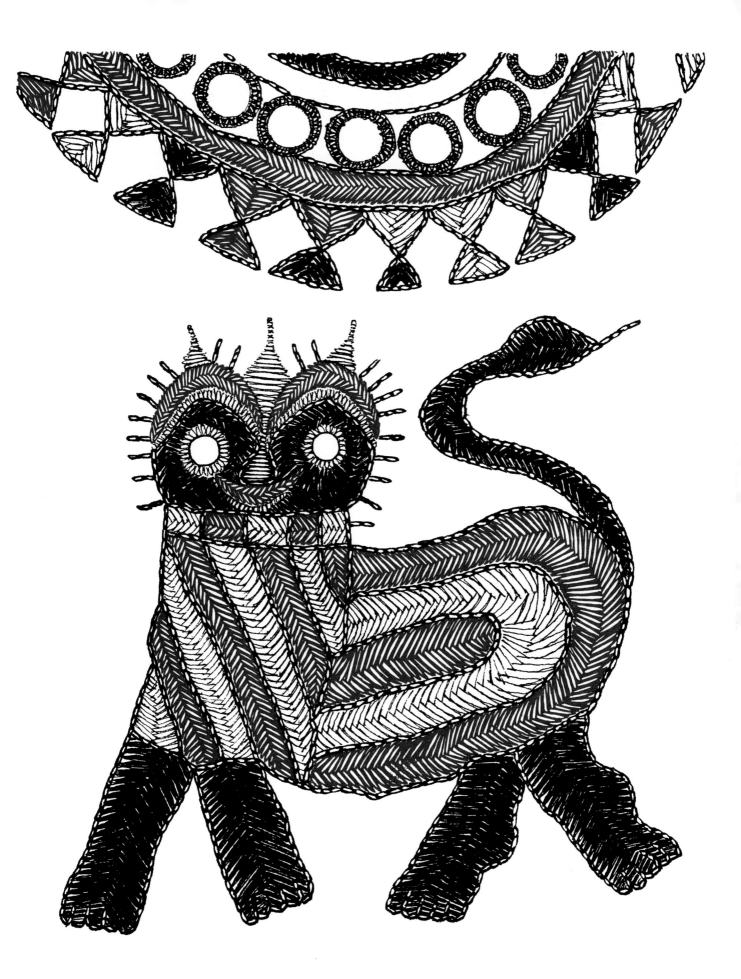

7   Wall hanging: lion. Kanbi school, Saurashtra.

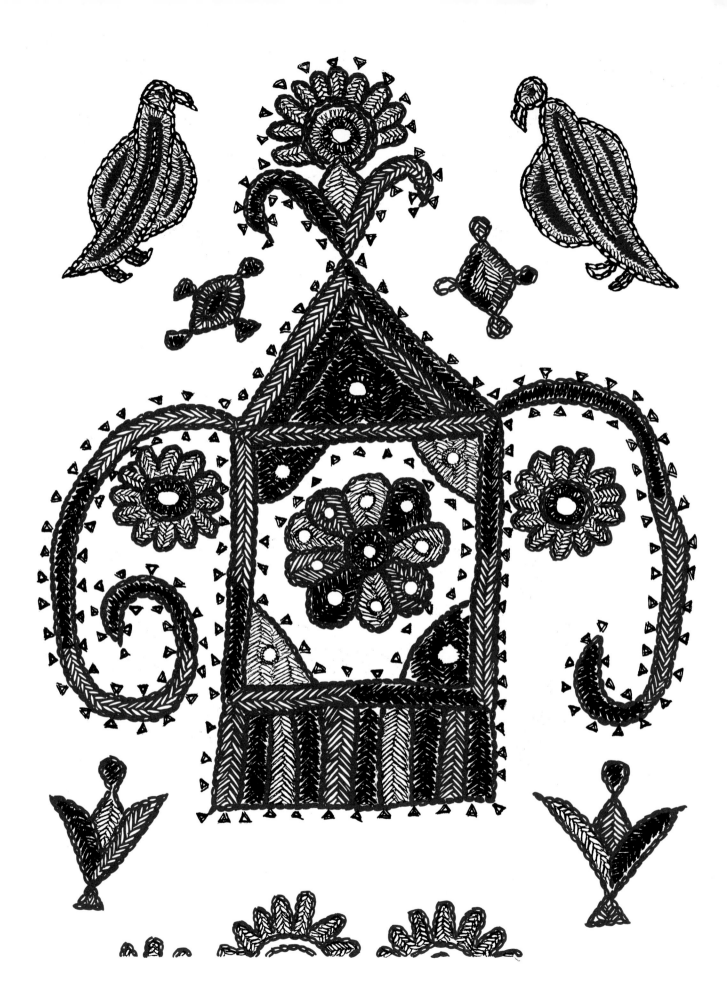

8   Wall hanging: stylized elephants and birds. Ahir school, Kutch.

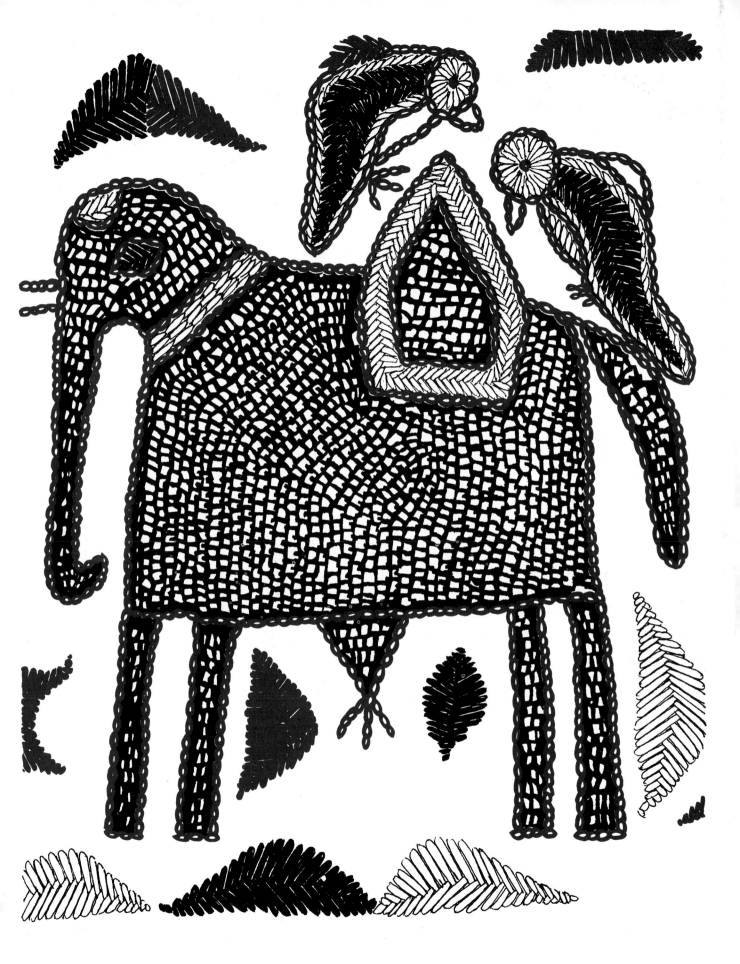

9   Wall hanging: elephant and birds. Kanbi school, Saurashtra.

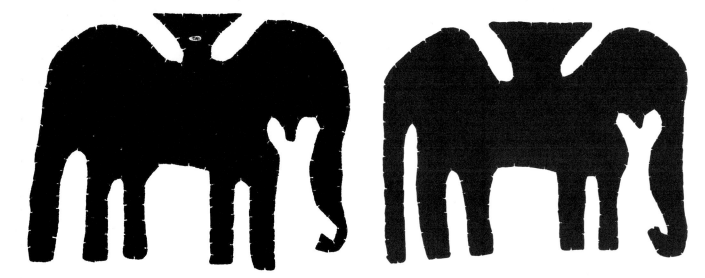

10 Wall hanging: elephants. Mahajan school, Saurashtra.

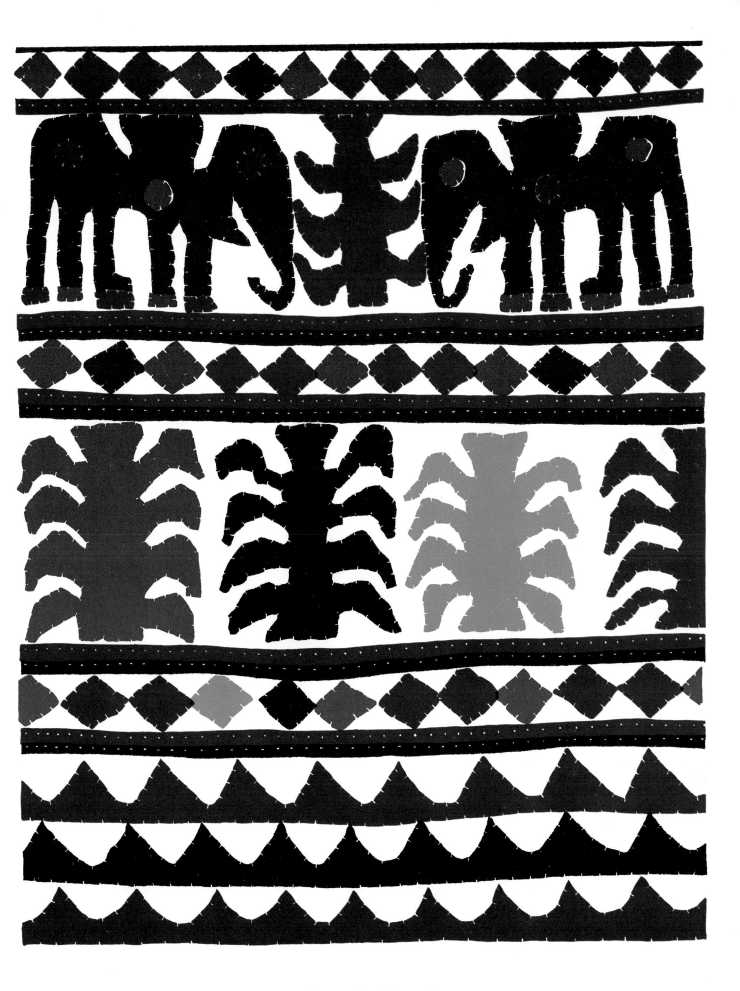

11   Wall hanging: elephants and trees. Mahajan school, Saurashtra.

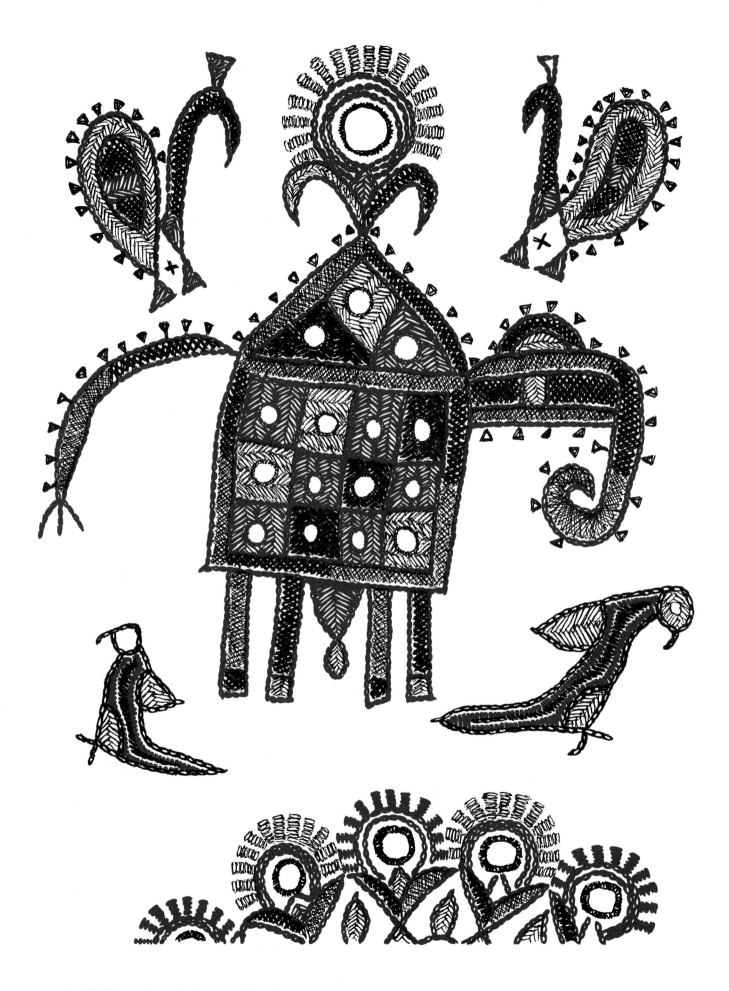

12   Wall hanging: elephant and birds. Ahir school, Kutch.

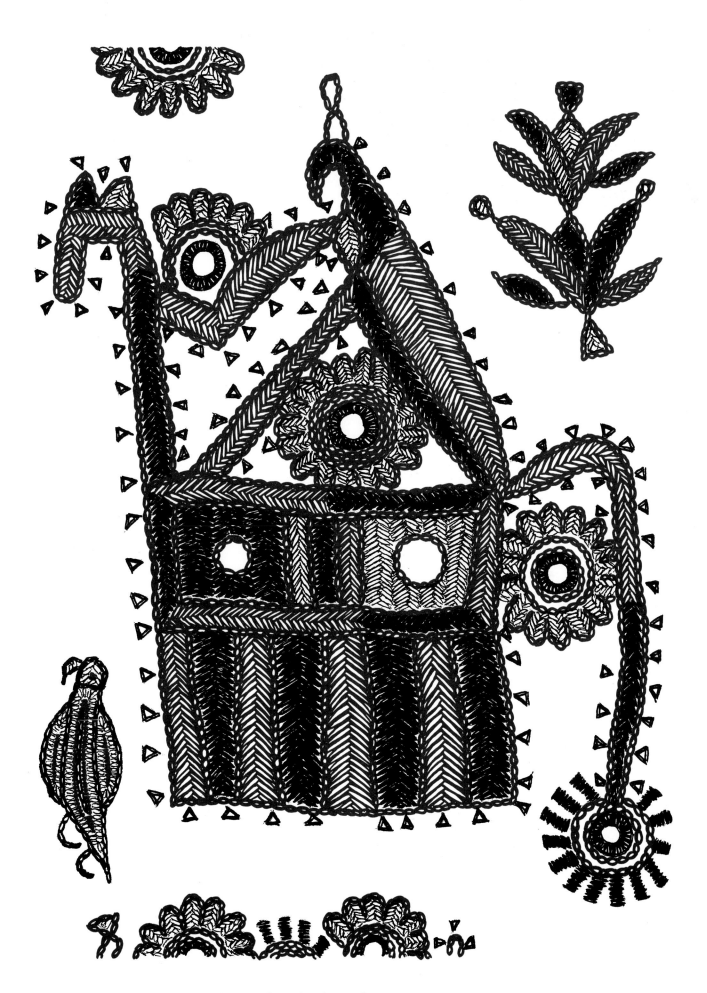

13   Wall hanging: camel and birds. Ahir school, Kutch.

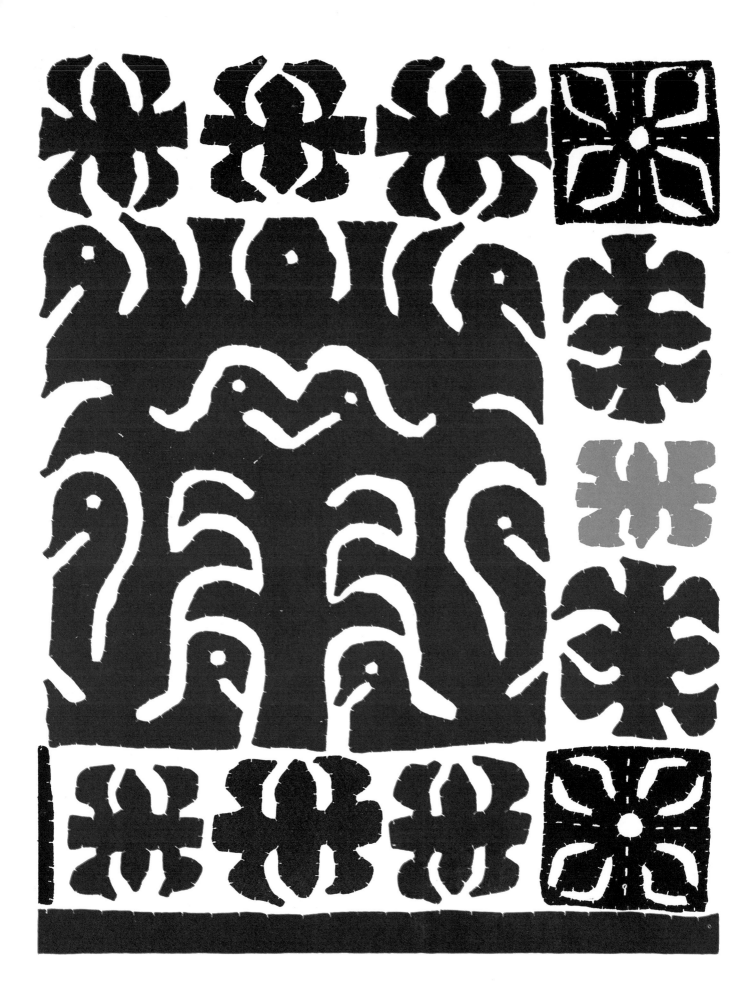

14 Appliquéd canopy: birds in a tree. Mahajan school, Saurashtra.

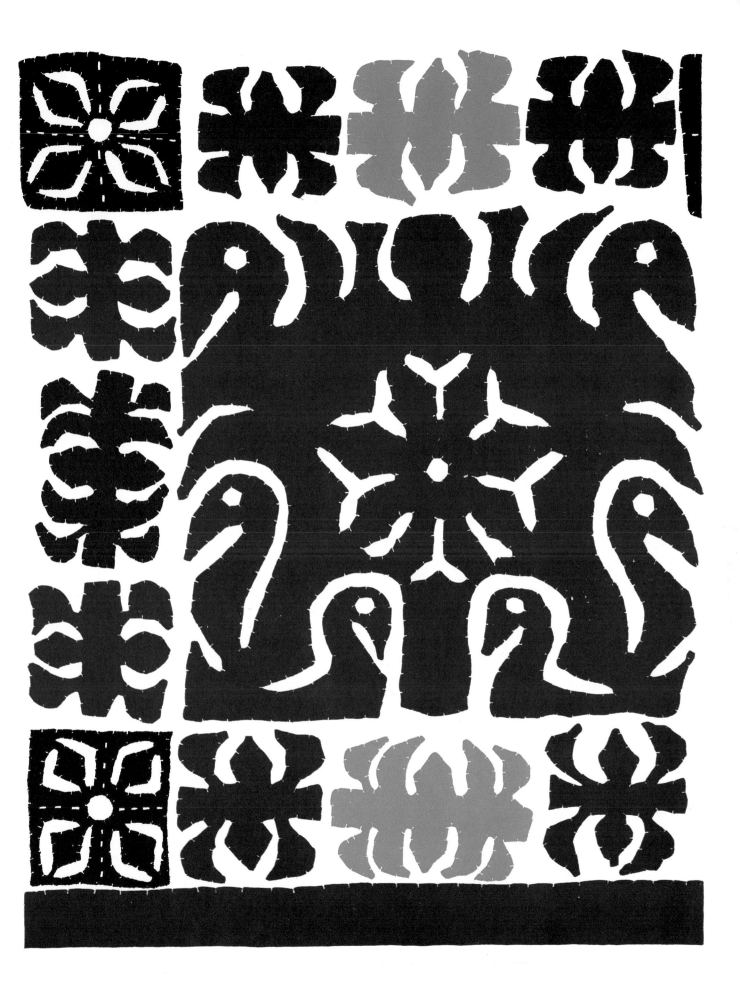

15  Appliquéd canopy: birds in a tree. Mahajan school, Saurashtra.

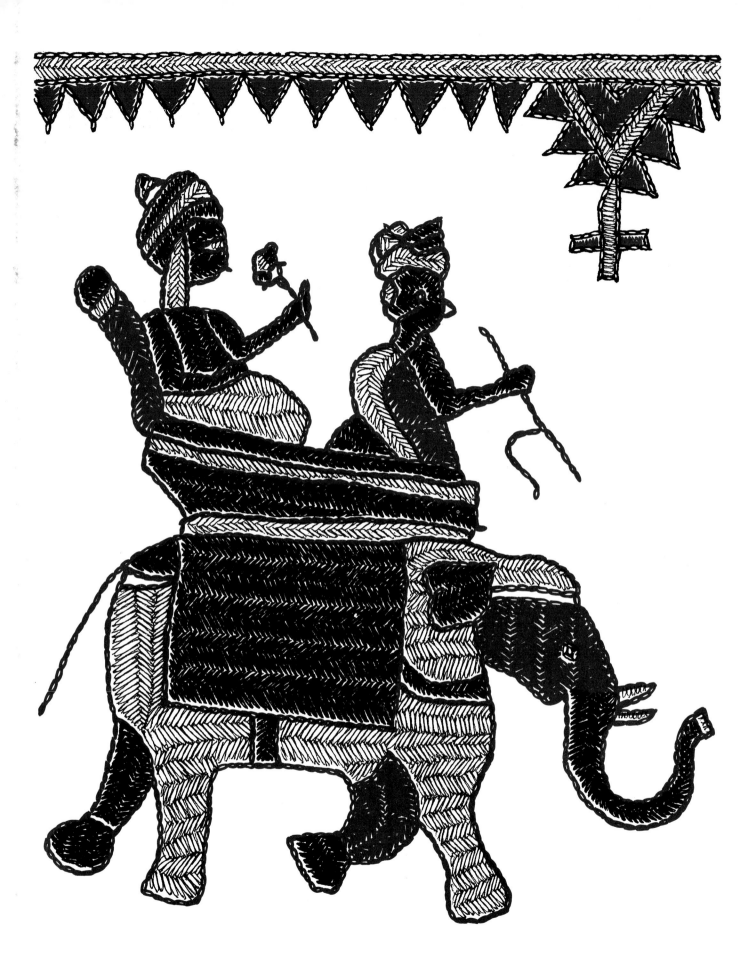

16   Wall hanging: king riding an elephant. Kathi school, Saurashtra.

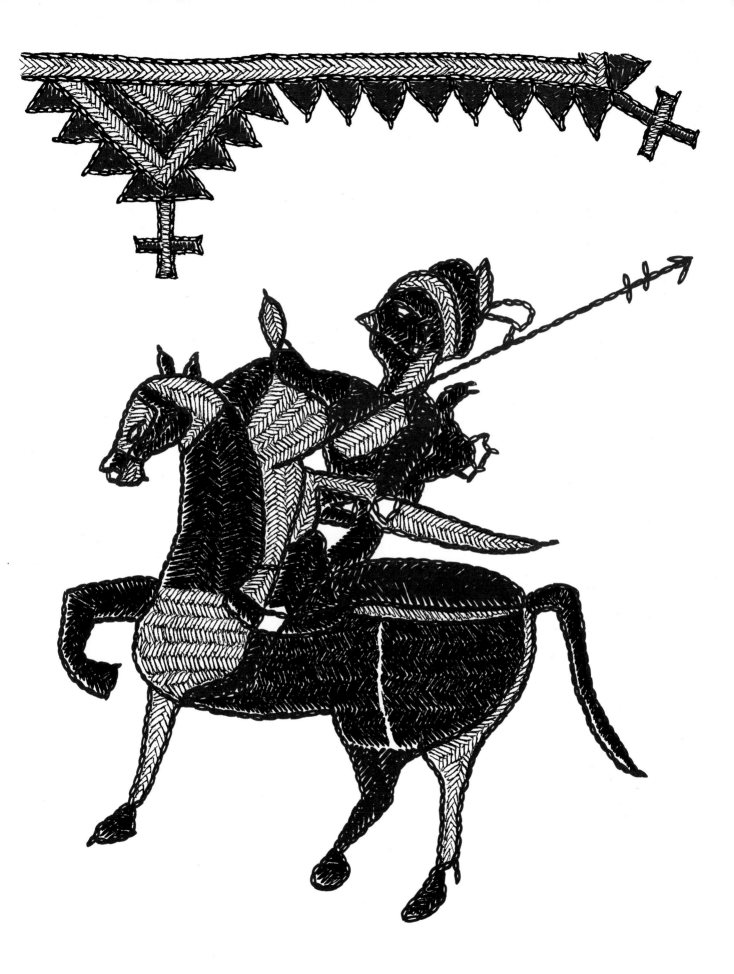

17   Wall hanging: cavalier. Kathi school, Saurashtra.

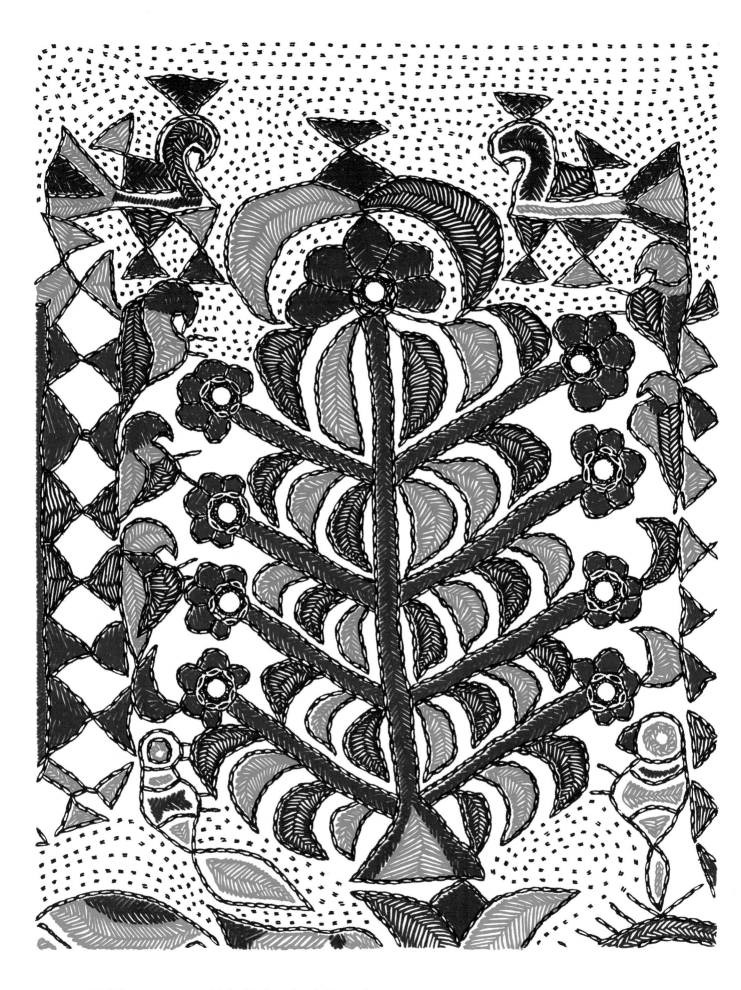

18   Wall hanging: tree of life. Kathi school, Saurashtra.

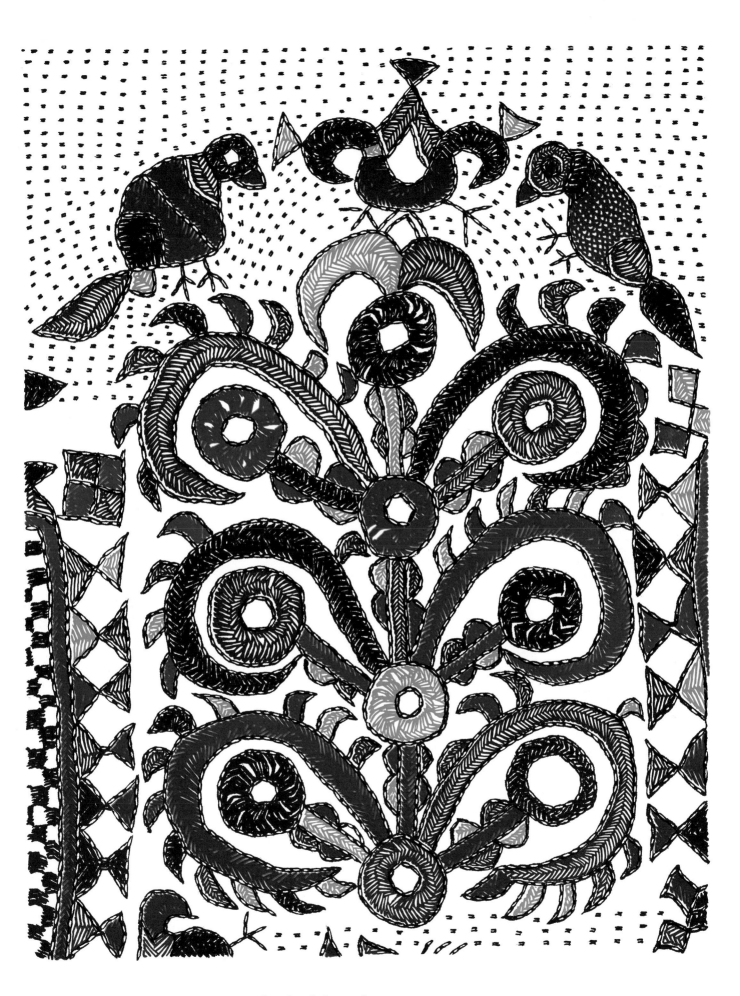

19    Wall hanging: tree of life. Kathi school, Saurashtra.

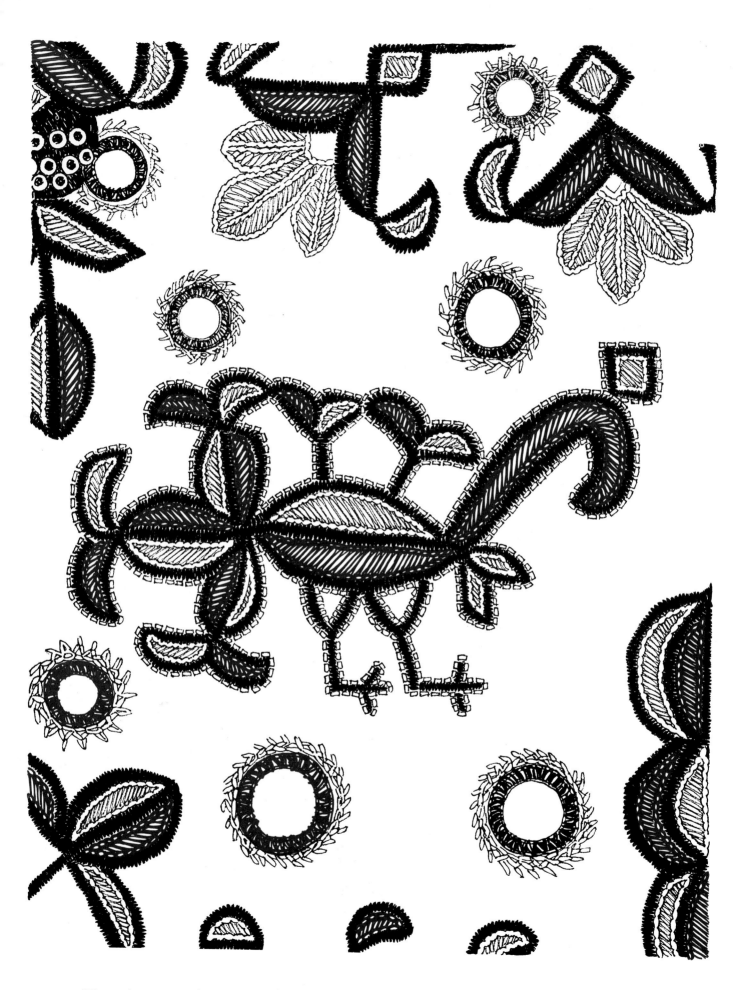

20   Woman's tunic: peahen. Banni school, Kutch.

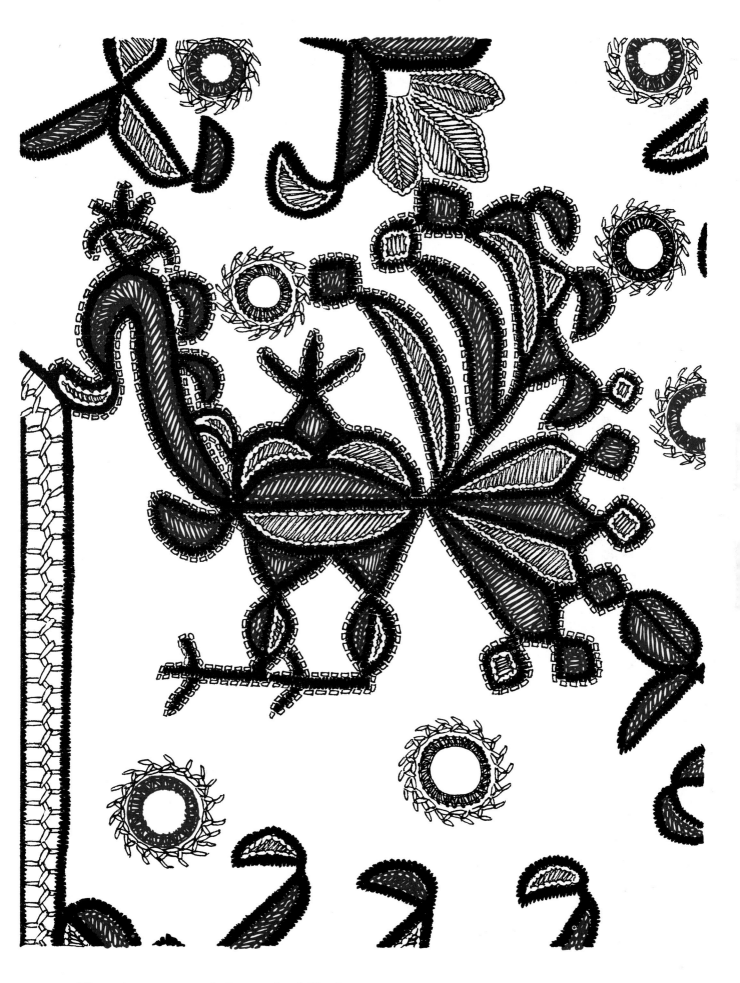

21　Woman's tunic: peacock. Banni school, Kutch.

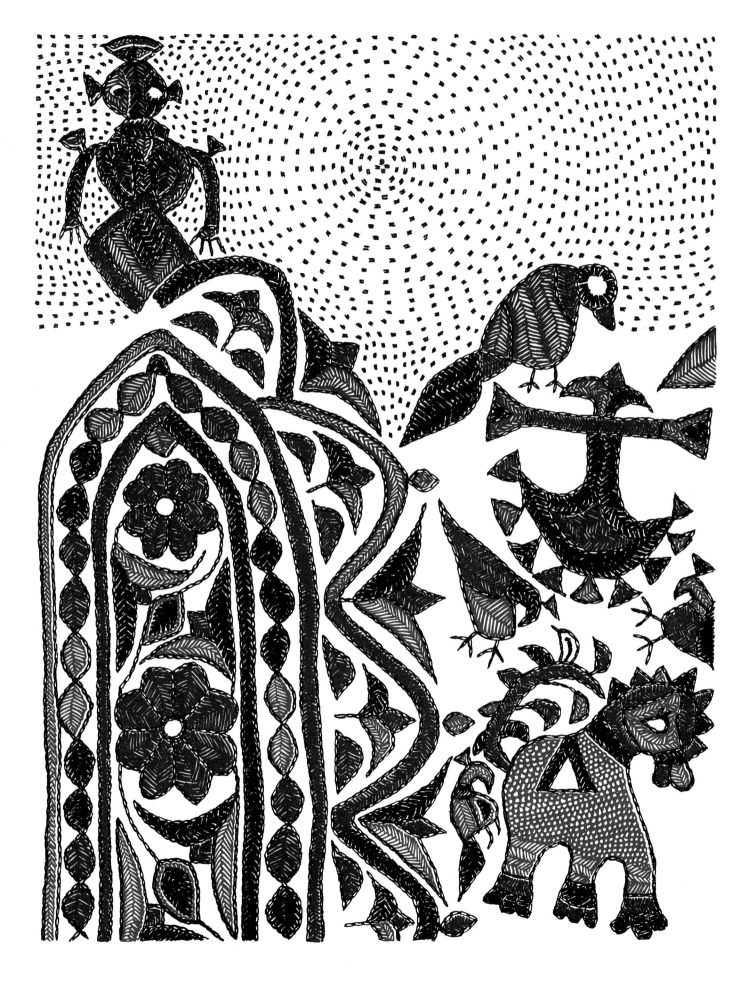

22   Wall hanging: floral border, horse, birds and human figure. Kathi school, Saurashtra.

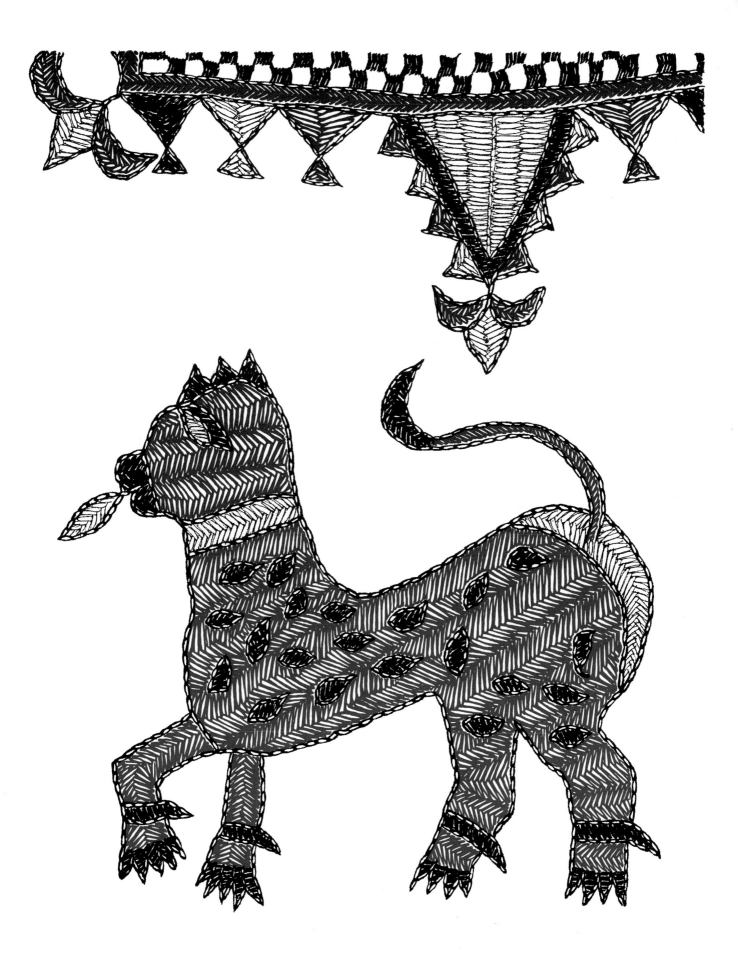

23  Wall hanging: leopard. Kathi school, Saurashtra.

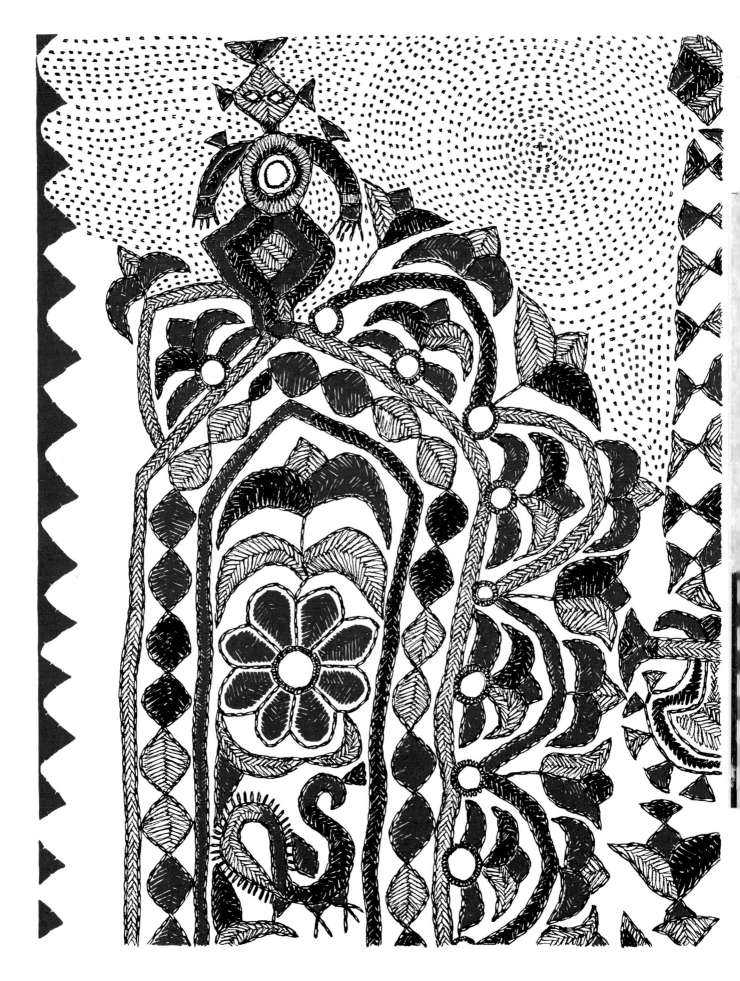

24   Wall hanging: floral border, bird and human figure. Kathi school, Saurashtra.

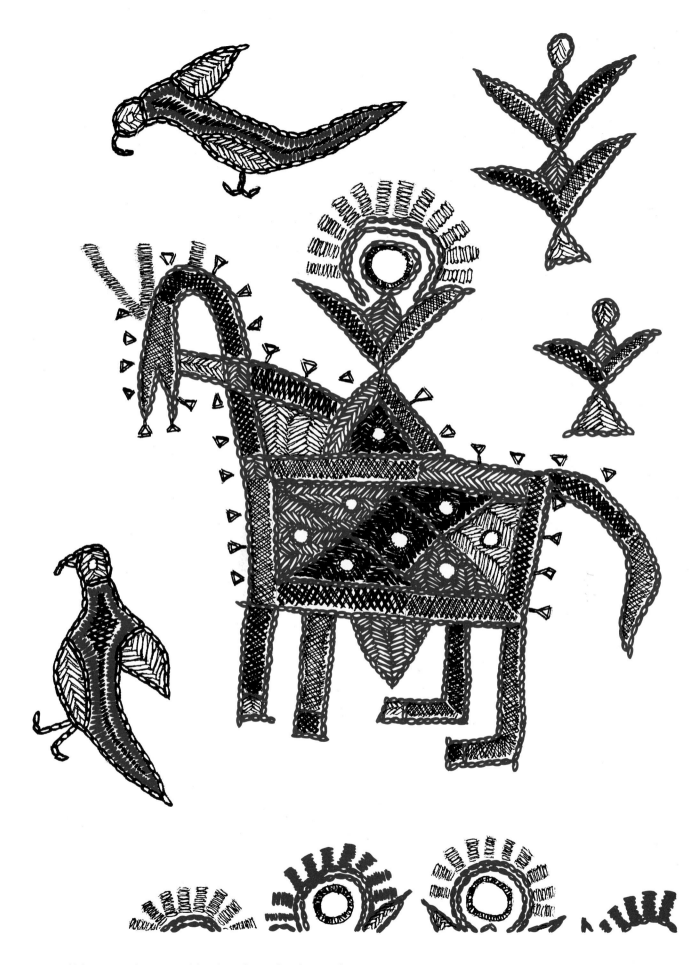

25  Wall hanging: horse and birds. Ahir school, Kutch.

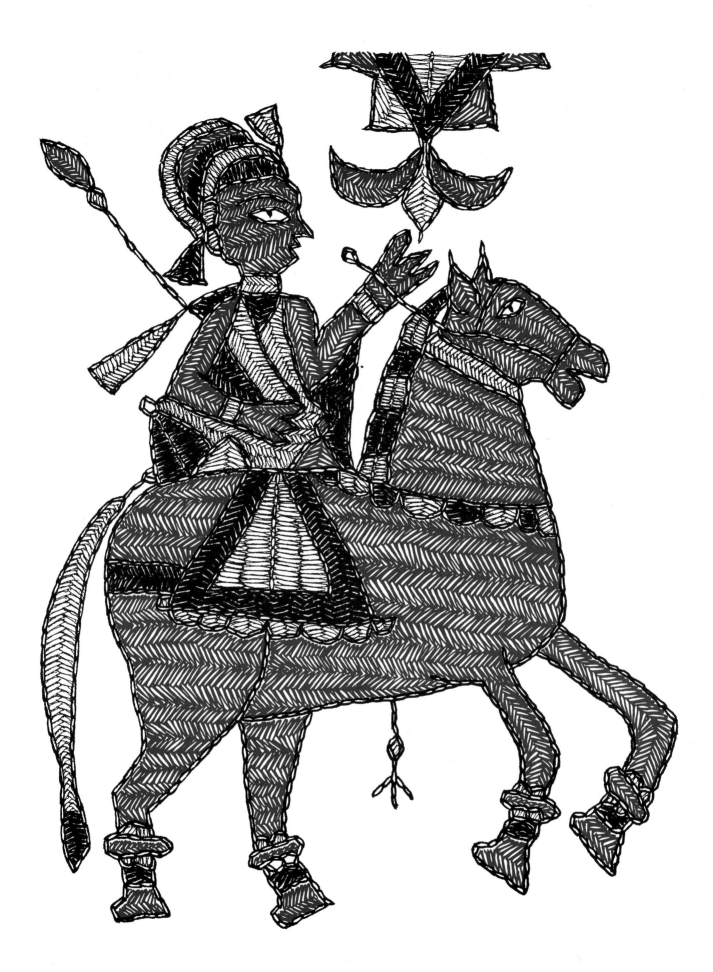

26   Wall hanging: cavalier. Kathi school, Saurashtra.

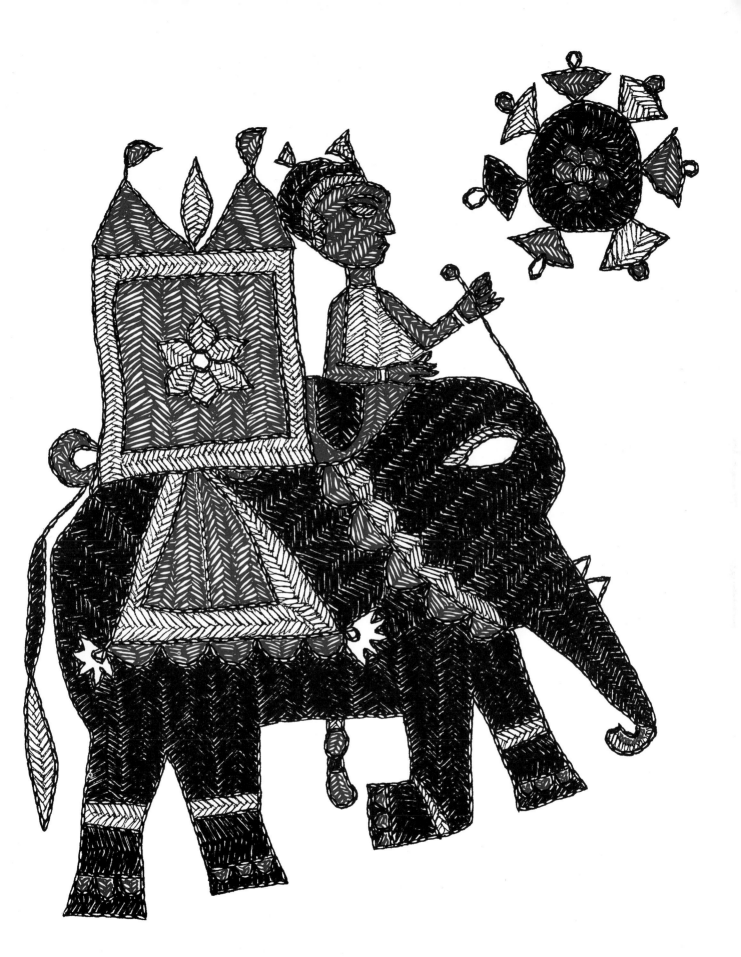

27  Wall hanging: royal elephant. Kathi school, Saurashtra.

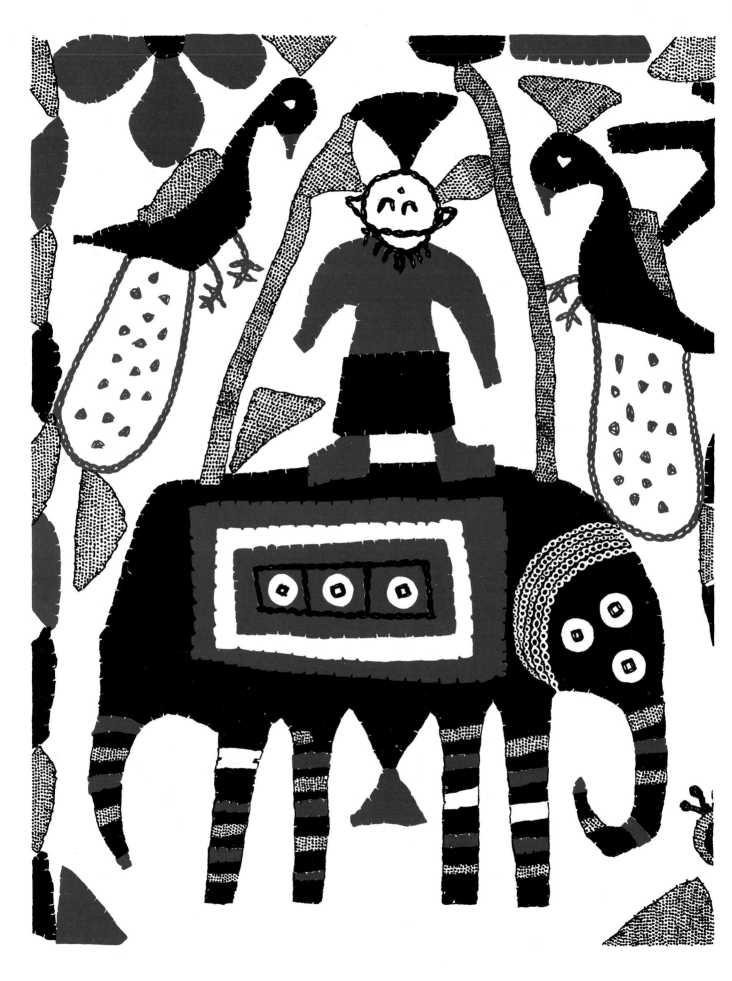

28    Appliquéd hanging: elephant, rider and peacocks. Rabari school, Kutch.

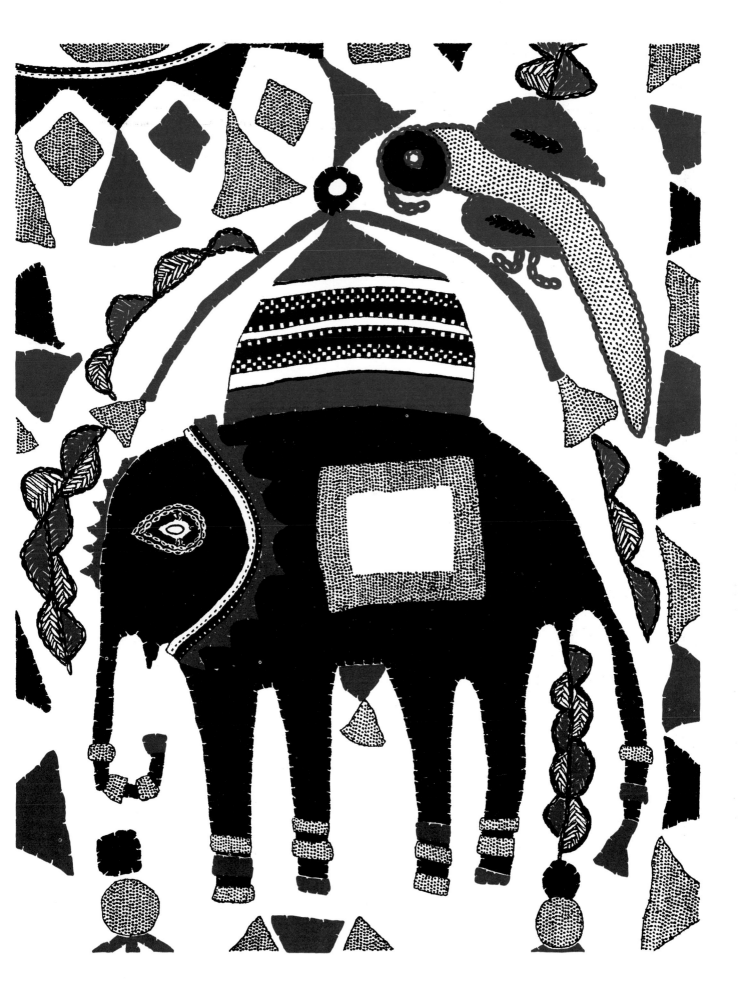

29  Appliquéd hanging: elephant and parrot. Rabari school, Kutch.

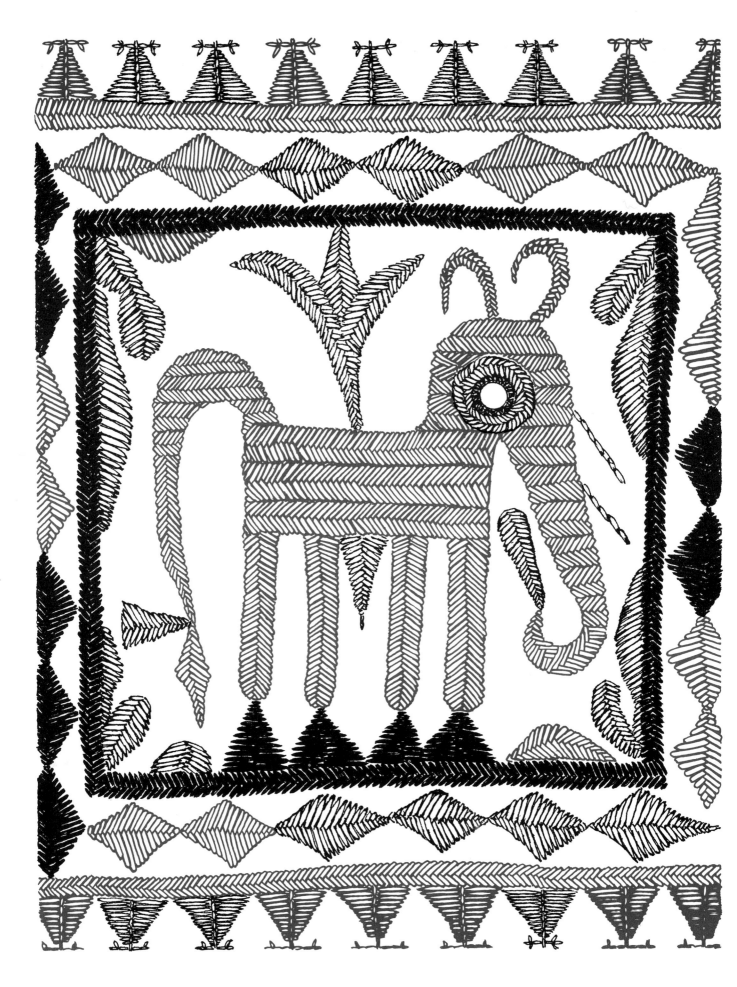

30  Door frieze: elephant. Kanbi school, Saurashtra.

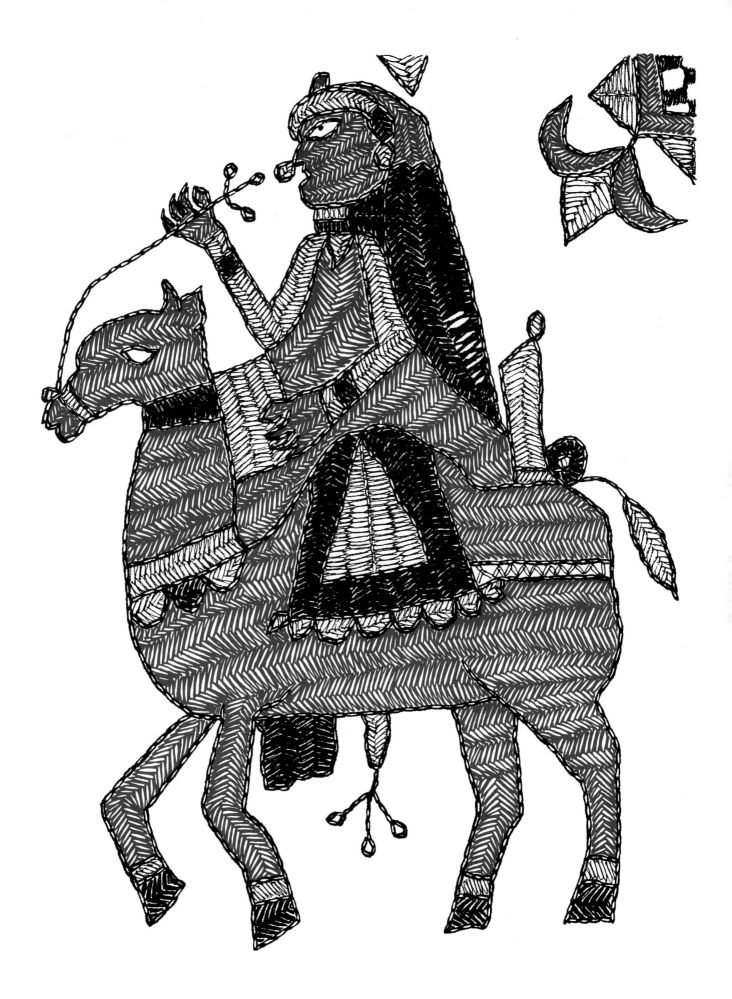

31   Wall hanging: lady on a camel. Kathi school, Saurashtra.

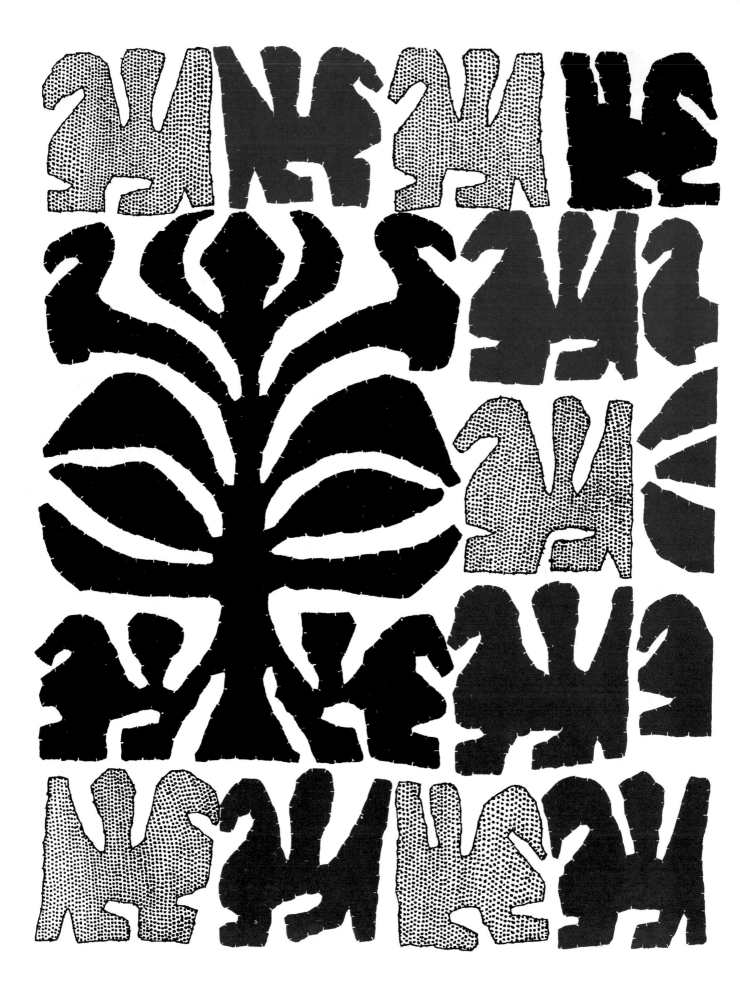

32 Appliquéd canopy: birds in a tree. Mahajan school, Saurashtra.

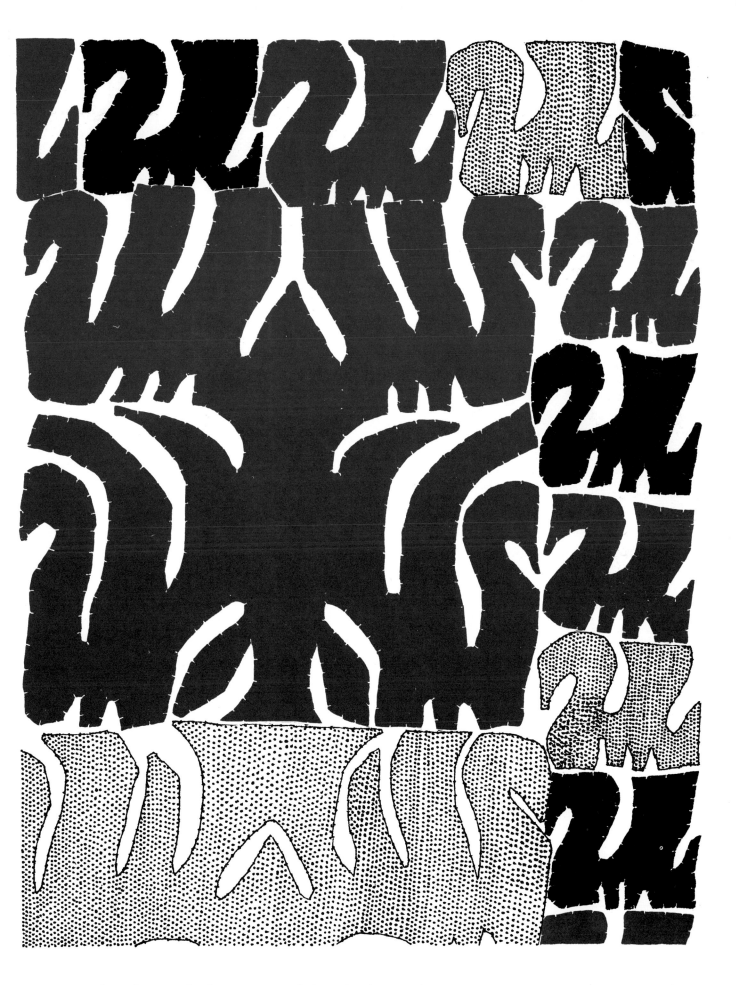

33  Appliquéd canopy: birds in a tree. Mahajan school, Saurashtra.

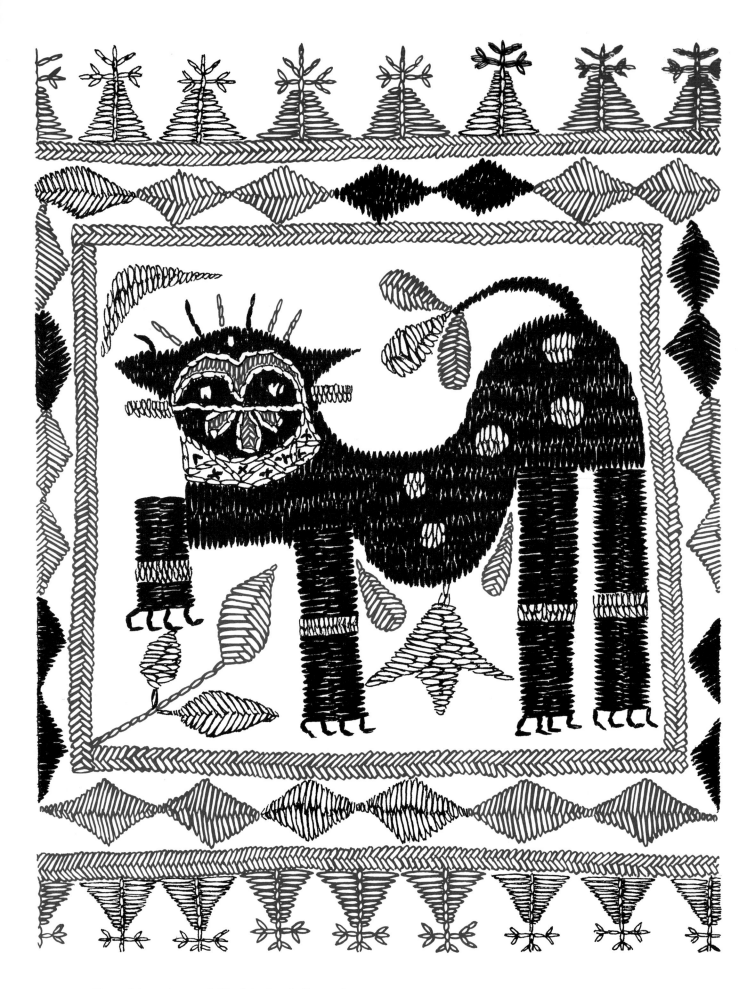

**34   Door frieze: leopard. Kanbi school, Saurashtra.**

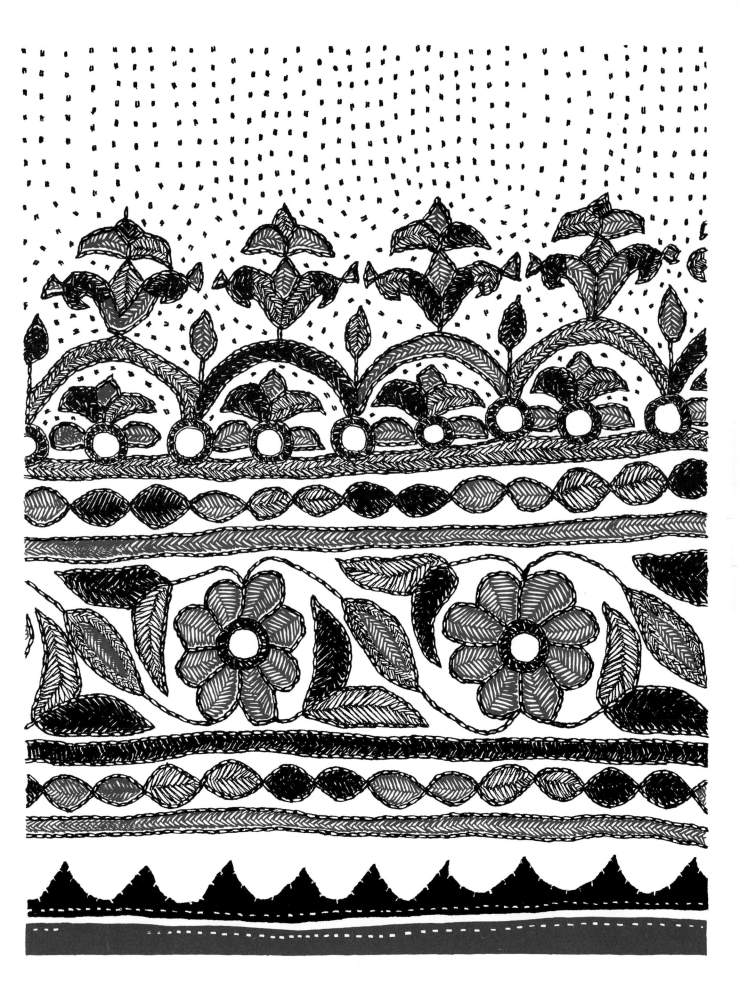

35   Wall hanging: floral border. Kathi school, Saurashtra.

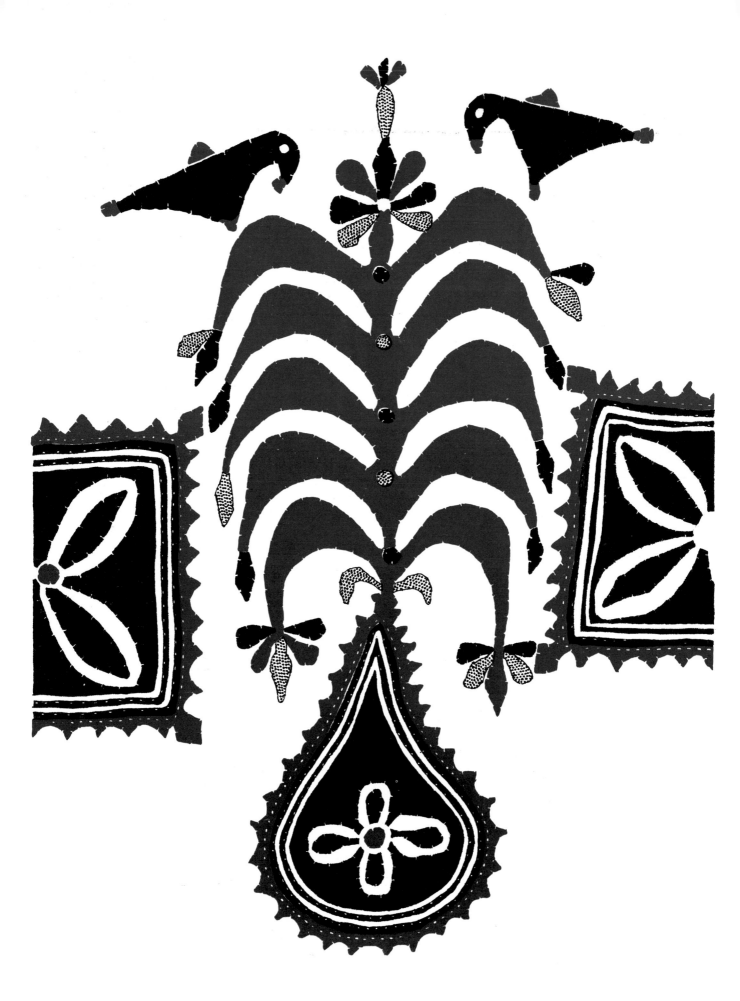

36   Appliquéd hanging: birds in a tree. Rabari school, Kutch.

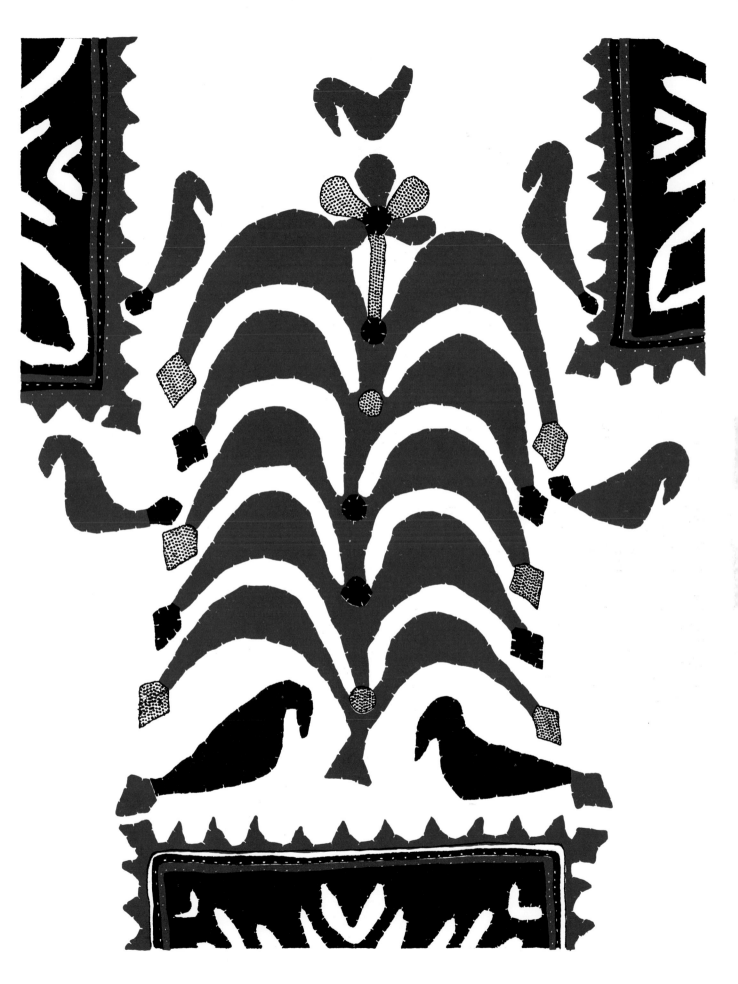

37   Appliquéd hanging: birds in a tree. Rabari school, Kutch.

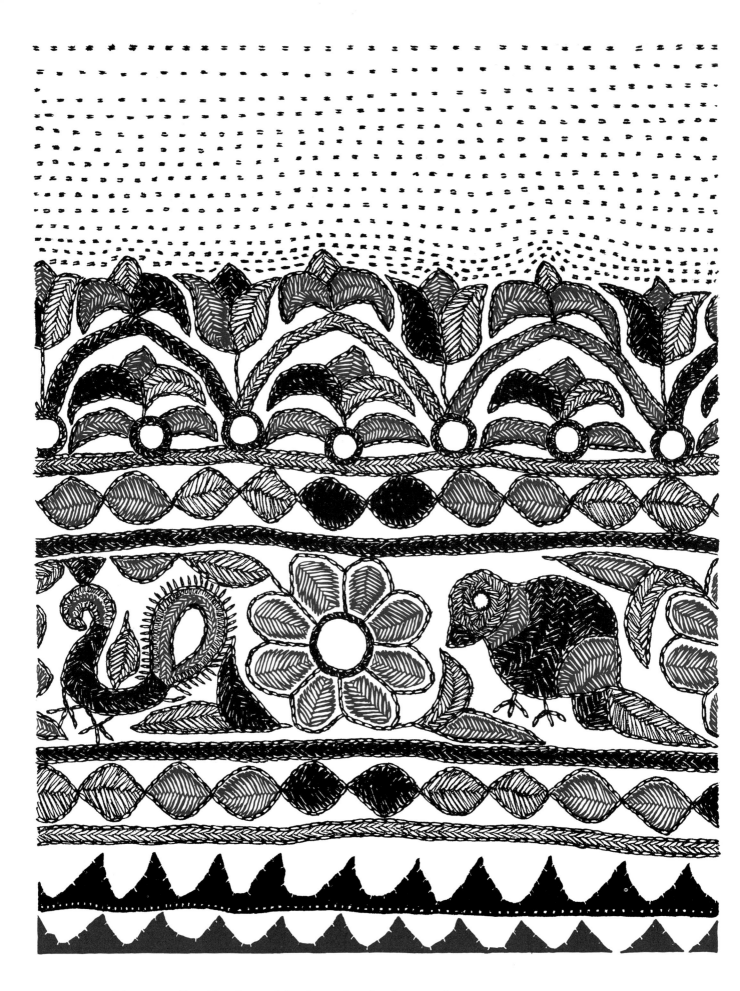

38   Wall hanging: floral border with birds. Kathi school, Saurashtra.

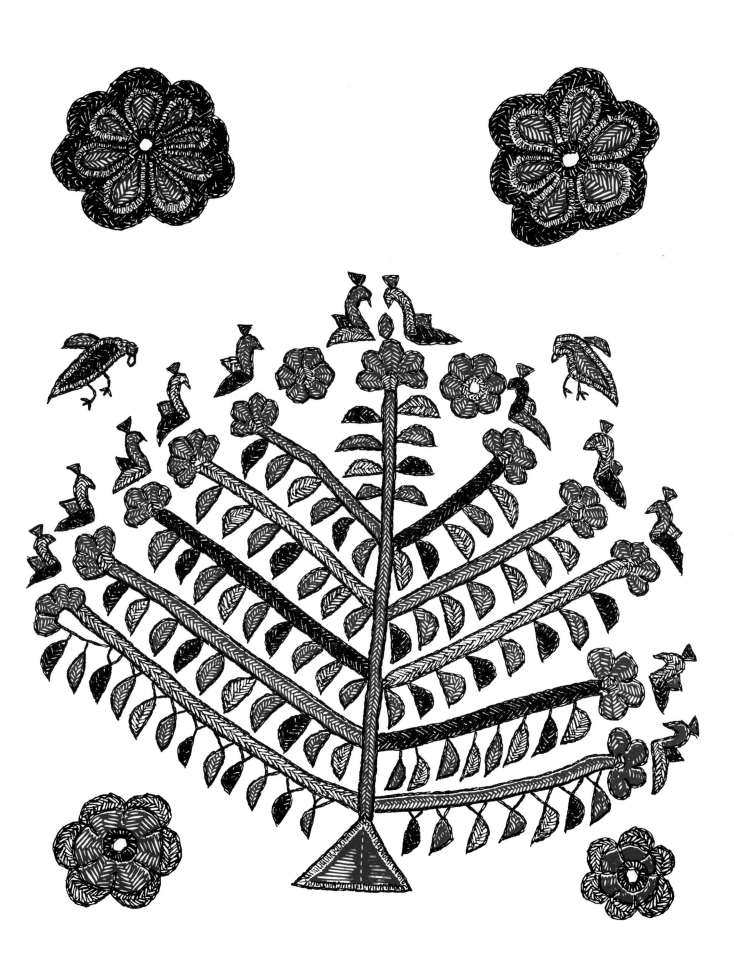

39 Wall hanging: tree and birds. Kathi school, Saurashtra.

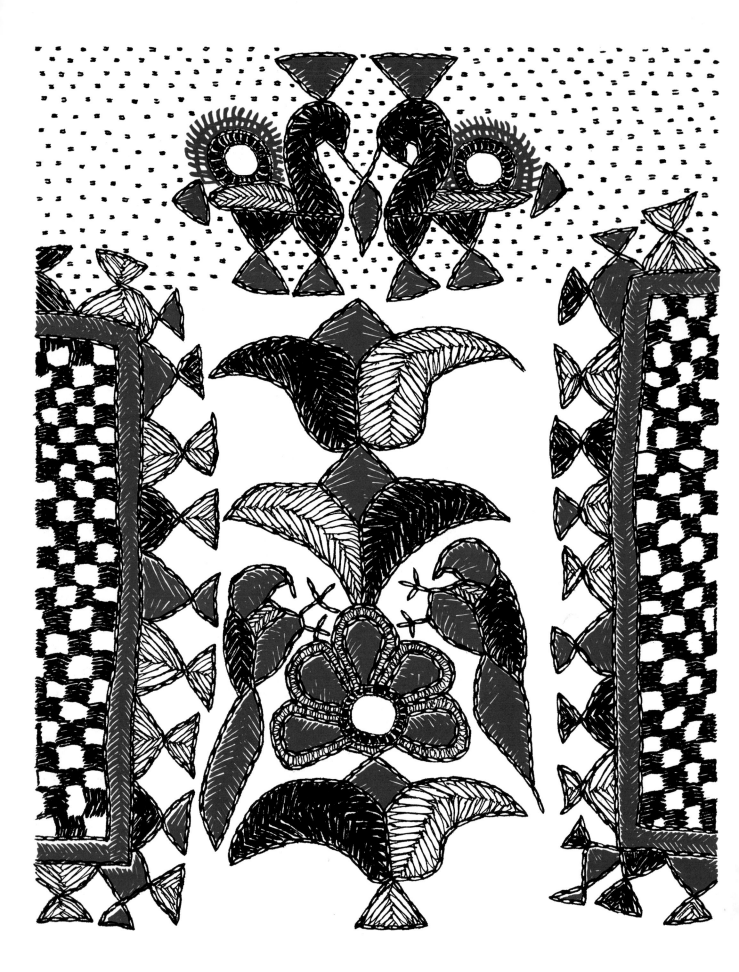

40 Wall hanging: plant and birds. Kathi school, Saurashtra.

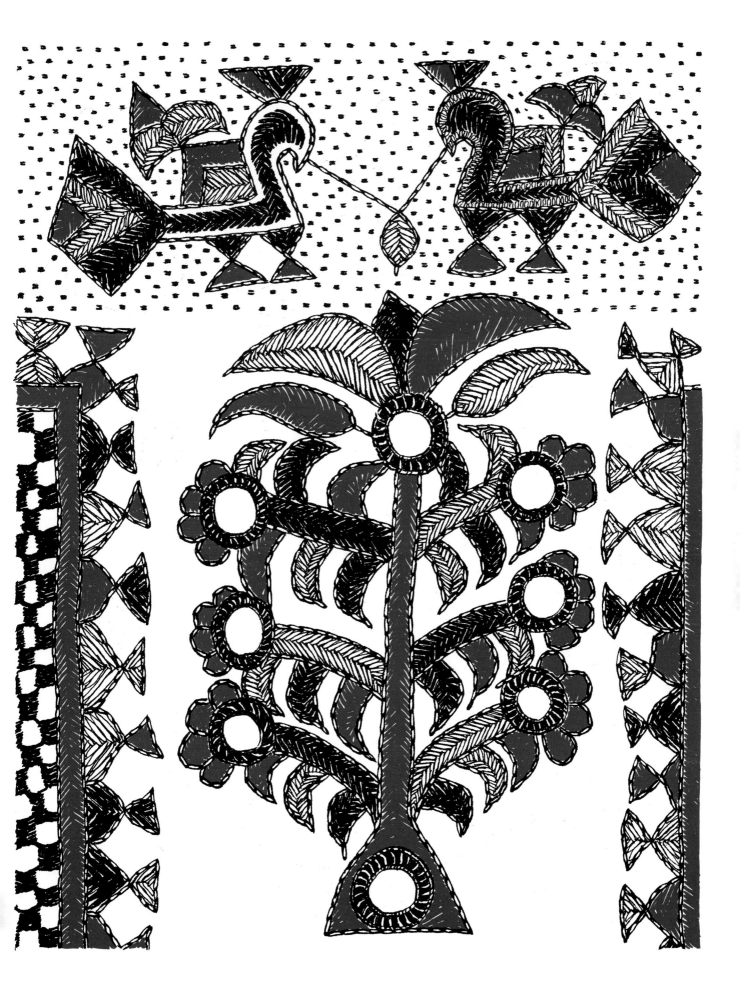

41   Wall hanging: tree of life and peacocks. Kathi school, Saurashtra.

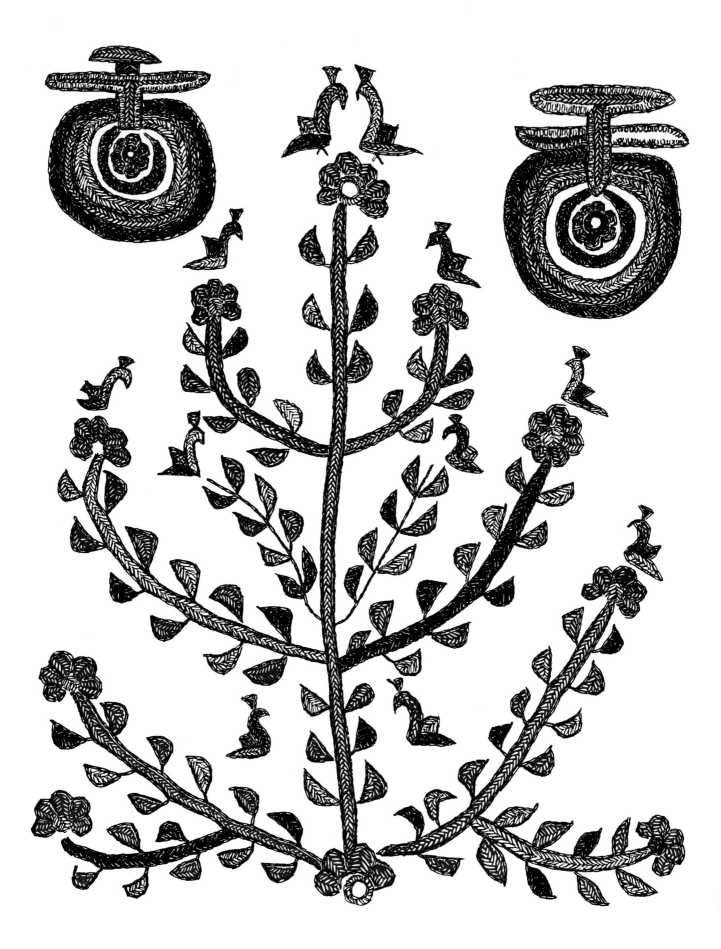

42   Wall hanging: tree and birds. Kathi school, Saurashtra.

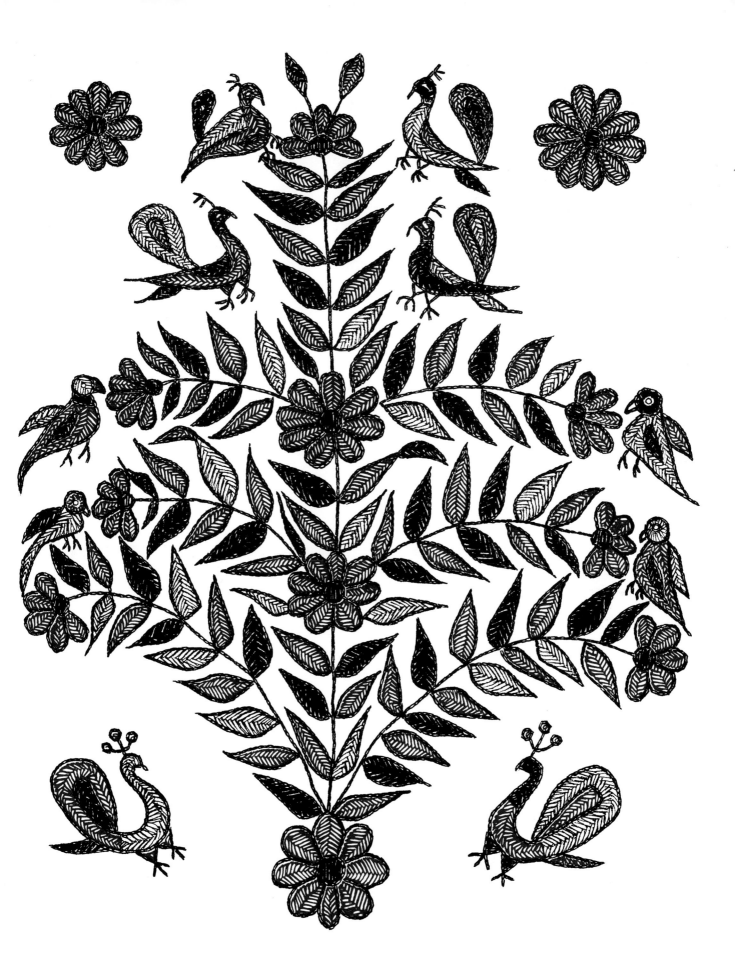

43   Wall hanging: tree of life. Ahir school, Kutch.

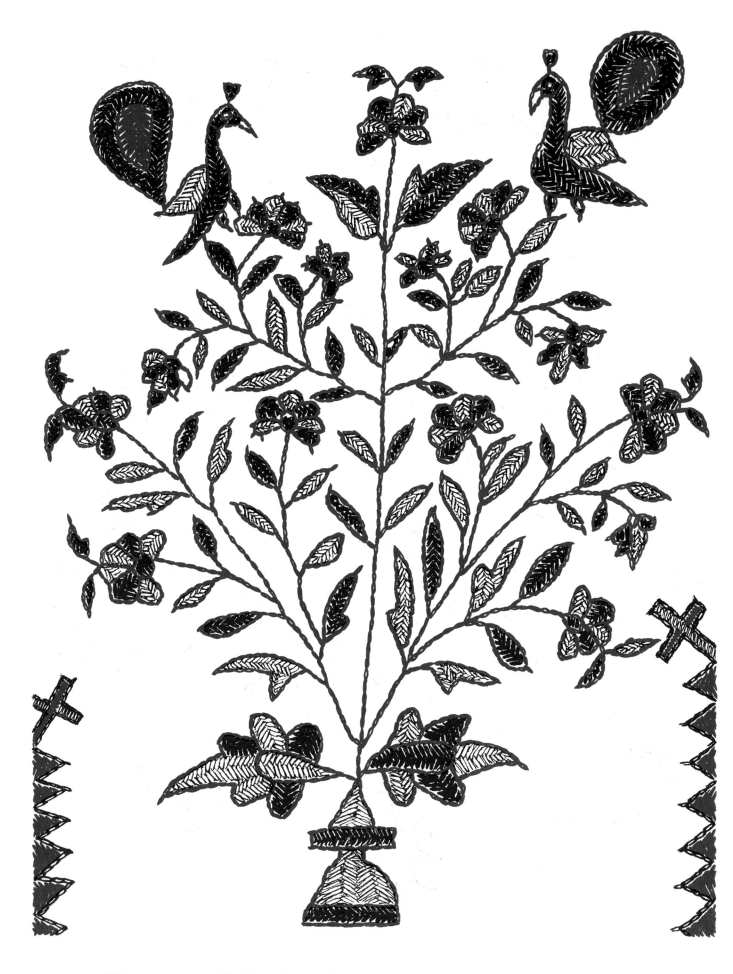

44    Wall hanging: tree and birds. Kathi school, Saurashtra.

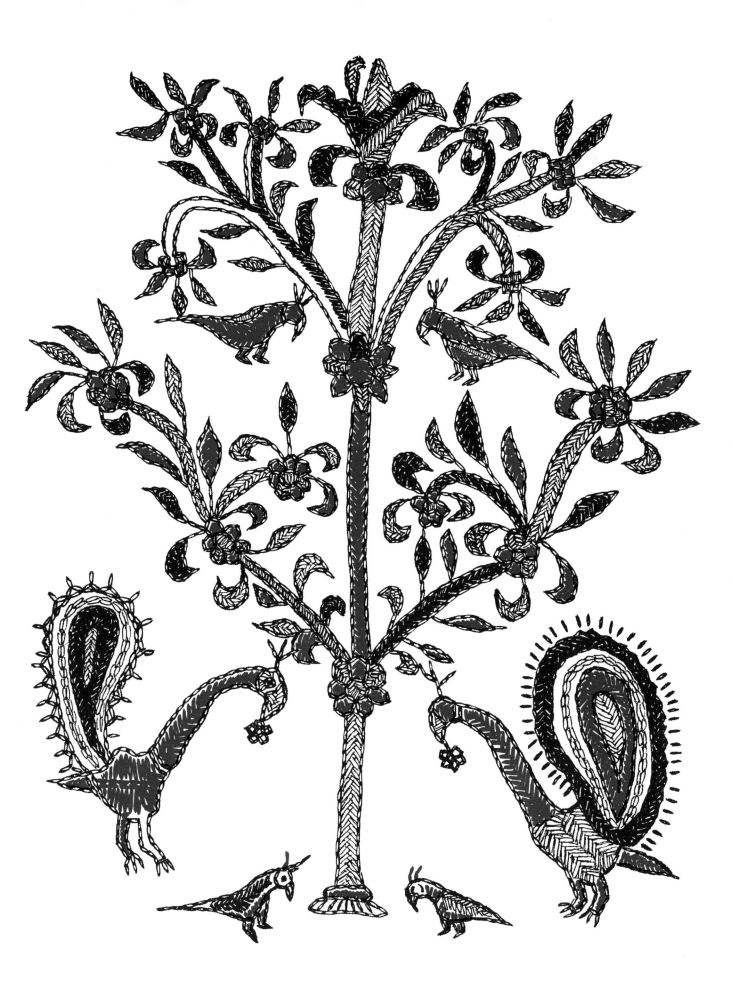

45  Wall hanging: tree and birds. Kathi school, Saurashtra.

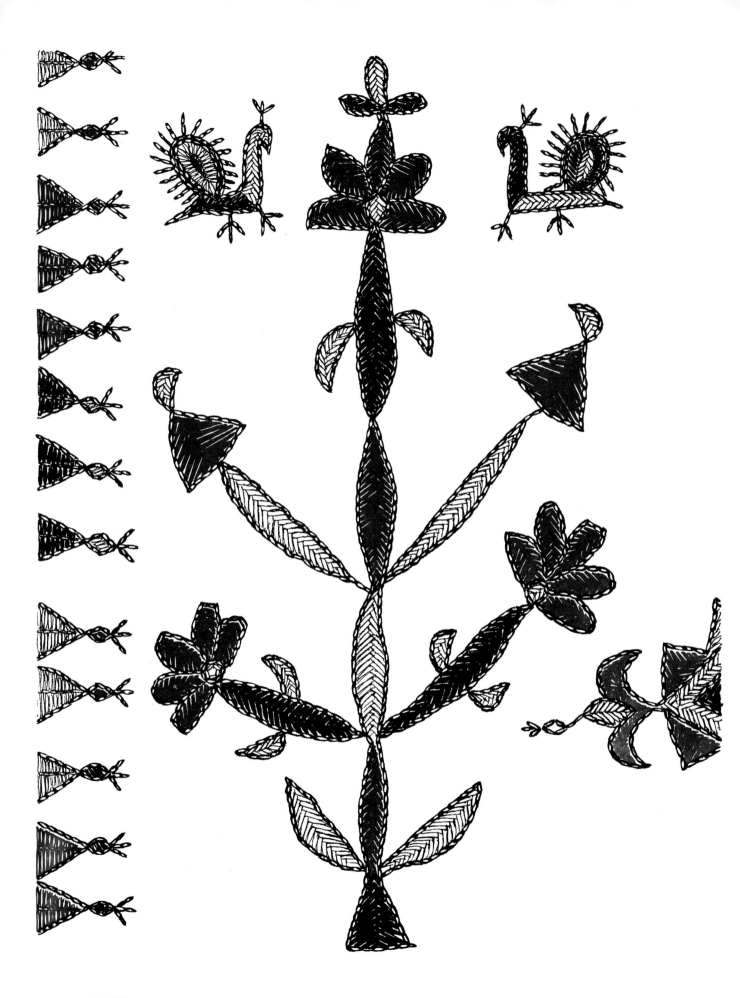

46　Wall hanging: plants and birds. Kathi school, Saurashtra.

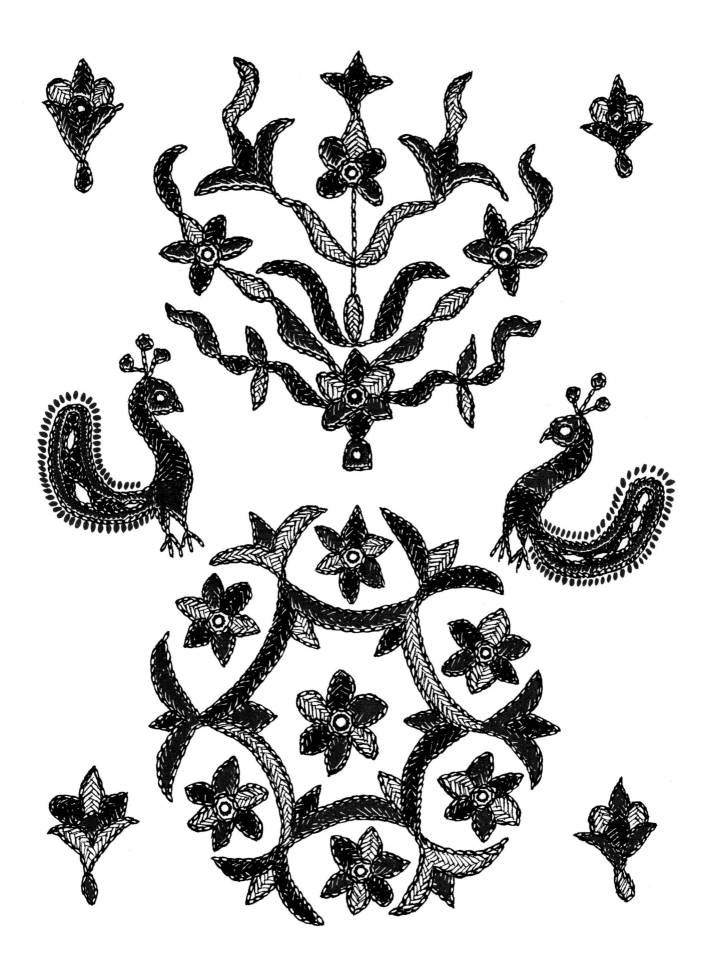

47   Wall hanging: plants and birds. Kathi school, Saurashtra.